D1591800

AMERICAN INTERESTS IN THE HOLY LAND
REVEALED IN EARLY PHOTOGRAPHS
FROM 1840 TO 1940

★ ★ ★ ★ ★ AMERICAN
INTERESTS
IN THE HOLY LAND
REVEALED IN EARLY PHOTOGRAPHS
— FROM 1840 TO 1940 —

LENNY BEN-DAVID

American Interests in the Holy Land Revealed in Early Photographs
From 1840 to 1940
by Lenny Ben-David

Typeset by Ariel Walden

First Edition

Printed in Israel

ISBN 978-965-524-235-5

Urim Publications
P.O. Box 52287
Jerusalem 9152102, Israel
www.UrimPublications.com

Library of Congress Cataloging-in-Publication Data
Names: Ben-David, Lenny, author.
Title: American interests in the Holy Land revealed in early photographs from 1840
 to 1940 / Lenny Ben-David.
Description: First Edition. | Jerusalem ; New York : Urim Publications, [2017]
Identifiers: LCCN 2017001227 | ISBN 9789655242355 (hardback)
Subjects: LCSH: Palestine—Pictorial works. | Americans—Palestine—Pictorial
 works. | Jews—Palestine—Social life and customs—Pictorial works. | Documentary
 photography—Palestine. | American Colony (Jerusalem)—Pictorial works. | BISAC:
 HISTORY / Middle East / Israel. | PHOTOGRAPHY / History.
Classification: LCC DS108.5 .B367 2017 | DDC 956.94/034—dc23 LC record available
 at https://lccn.loc.gov/2017001227

This book is dedicated in memory of our parents

Hena and Oskar Oliner

who, after surviving the Holocaust in Poland
through the grace of God,
found shelter and opportunity
in our great United States of America

and

Margie and Shimon Sumner

who were proudly
born and educated in Brooklyn, NY.

Our parents displayed great patriotism
for America as well as a passion for the Jewish Homeland,
Eretz Yisrael. Their sparkling example of philanthropy
and good deeds steers our efforts
on behalf of *Klal Yisrael.*

REVA and MARTY OLINER
Lawrence, NY
January 2017

‏נ״ז‎ 2017

Contents

INTRODUCTION
Antique Photographs: Silent Witnesses Speak Volumes 9

ACKNOWLEDGMENTS 15

1 Two Shining Cities Built on a Hill 18

2 American "Manifest Destiny" in the Holy Land in 1847 25

3 The Secret Identity of American Preacher
 Mendenhall John Dennis (AKA Mendel Diness of
 Jerusalem) 30

4 What Lincoln Would Have Seen in Jerusalem 35

5 The Humbugged American Colony in Jaffa 41

6 Mark Twain in the Holy Land in 1867 with the
 "Innocents Abroad" 48

7 Why is an American Flag on this "Vehicle"? 59

8 Ulysses S. Grant's Very Long Voyage to the Holy Land 61

9 Can't Sail to the Holy Land – Visit Chautauqua, NY 70

10 The American Welcoming Committee for Yemenite
 Jewish Pilgrims to Jerusalem 130 Years Ago 75

11 Bringing the Holy Land to America, Together with
 Mark Twain's Guide 85

12 Madam Lydia, Diva of the Holy Land 90

13 Theodore Roosevelt and the Holy Land – "Bully for You!" 99

14 Celebrating July 4th in the Holy Land 100 Years Ago 105

15 Waters of the Jordan Flowed to Kentucky in 1906
and Muddied an Anti-Semitic U.S. Diplomat's Reputation 110

16 Why an American Flag Flew on a Jerusalem
Steamroller 100 Years Ago 116

17 Americans and Canadians Join the War to Liberate
Palestine in 1917 120

18 Getting to Know the Jewish Legionnaires from
100 Years Ago: David Blick of Brooklyn and Leon
Cheifetz of Montreal 125

19 The U.S. Navy Saved the Jews of the Holy Land 100
Years Ago 130

20 U.S. Diplomat Saved Jews in 1915 but Opposed the
Zionist Idea in 1920 143

21 Chief Rabbi of Palestine Goes to the White House, 1924 148

22 Americans Were Outraged by the 1929 Hebron
Pogrom and a U.S. Diplomat's Anti-Semitic Reaction 153

23 U.S. Congressional Support – before the Holocaust
and Israel's Formation 159

24 Bonus: Bobby Kennedy's 1948 Visit to the Palestine
Front Lines 167

★

25 PREVIEW: World War I in the Holy Land Revealed in
Early Photographs from 1914 to 1919 171

PHOTOGRAPH CAPTION ENDNOTES
(in Roman numerals) 179

Introduction

Antique Photographs: Silent Witnesses Speak Volumes

THE LIBRARY OF CONGRESS ONLINE REFERENCE READ, "JEWISH SET-tlements and colonies in Palestine." *Colonies?*

That piqued my interest five years ago while I was looking through the Library of Congress online archives for a document on U.S. Middle East policy.

The file led me to a 115-year-old treasure trove of pictures taken by the Christian photographers of the American Colony in Jerusalem, some showing Jewish "colonies" in the Galilee. The thousands of photographs digitized by the U.S. Library of Congress and by large and small archives around the world that I subsequently discovered, provided dramatic proof of thriving Jewish communities in Palestine in the 19th century. Hundreds of photos portray the ancient Jewish communities in Jerusalem, Jaffa, and Tiberias as well as the Jewish pioneers and builders of new towns, industries, and settlements in the Galilee and along the Mediterranean coast.

And I rediscovered America. The collections revealed American visits to the region from 100–150 years ago by individual tourists, senior government officials, members of Congress, and U.S. Navy ships. For the Americans who were unable to visit the Holy Land, proof of its existence and growth arrived on the shores of the United States by way of the vast collections of these photographs.

Contrary to a recent claim by a senior Israeli archivist that "the American

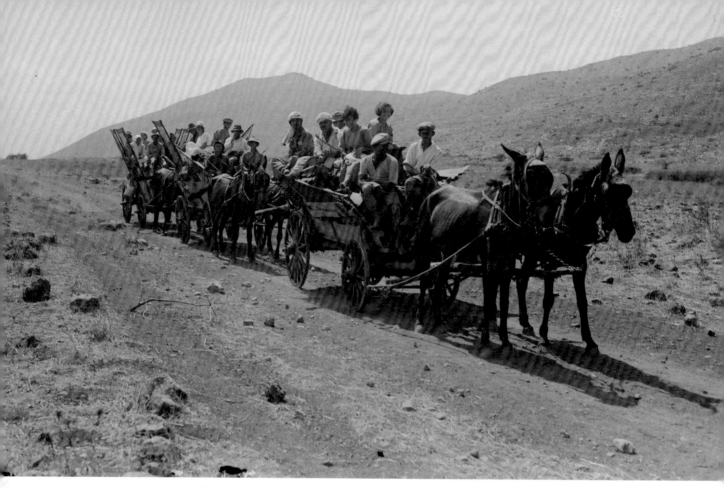

"Jewish colonies and settlements. Commencing a Jewish settlement; a camp. Jewish settlers arriving, circa 1920." (*Library of Congress*)[i]

Colony photographers . . . rarely photographed Zionist events,"[1] the abundance of photos of Christian, Muslim, *and* Jewish sites taken by the American Colony Photo Department proved otherwise. Indeed, there are hundreds of pictures recorded of Jewish holy sites, holiday scenes and customs, Yemenite Jews, historical events, recreations of Biblical stories, Zionist communities, farms, industries, and Jewish children. The wonderful picture on page 13 is one such example, displaying a very large crowd of Jewish men, women and children at a procession apparently celebrating the Jewish holiday of Lag B'Omer.

1. Lavi Shay, "The Development of Photography in Jerusalem, 1839 to 1948," quoted in "Jerusalem through the Lens of Yore," *In Jerusalem, The Jerusalem Post*, June 3, 2016.

From the mid-nineteenth century onward, using the recently developed technology of photography, a new art form appeared on the scene, depicting Jewish devotion to Jerusalem, the Holy Land, and the Bible. Steamships opened the Middle East to travelers, explorers, writers, missionaries, and photographic pioneers in the 1850s and 1860s, such as Felix Bonfils, Francis Frith, James Graham, Elijah Meyers, Peter Bergheim, and Frank Good. Most of these visitors recorded their photographs on glass plates, providing amazingly clear resolution, allowing modern-day researchers to discover historic details through enlargements of many of these gems. These photos provide a window, rarely opened by historians, into Jewish life in the Holy Land 100 years before the founding of the modern State of Israel.

Why this Emphasis on Jewish History?

Perhaps by oversight or malicious intent, some historic photographic albums and collections ignore the graphic proof of Jewish life in the Holy Land over the last 160 years. For some, the vintage photographs interfere with their narrative that the Jews in Palestine came only after the Holocaust of World War II. In the *Jerusalem Quarterly* of 2010, published by the Ramallah-based Institute for Palestine Studies, Prof. Barbara Bair wrote, "[The American Colony photographers] took photographs of sacred sites, such as the Mosque of Omar and the Church of the Holy Sepulchre."[2] She made no mention of the many Jewish sites photographed by the American Colony's photographers – the Western Wall and Rachel's Tomb to name but two.

The American Colony Hotel in Jerusalem, a favorite haunt for Palestinian leaders and supporters as well as journalists visiting from overseas since the 1980s, provides guests complimentary copies of "The American Colony Family Album," published in 2008. Despite the presence of so many photographs of Jewish life in the Land of Israel found in the American Colony

2. Barbara Bair, "The American Colony Photography Department: Western Consumption and 'Insider' Commercial Photography," *Jerusalem Quarterly*, Winter 2010.

photo collection from which the album derived its contents, only one photo of Jews was included – several old women at the Western Wall.[3]

Essential to Preserve Historical Photographs

Like the Library of Congress, other libraries and archives realized the pressing necessity to preserve their photographic treasures, digitize them, and put them online. I have now surveyed thousands of photographs in the digital collections of Harvard University, the New York Public Library, the British Museum Endangered Collections, the French National Library, Getty Library, Chatham University, University of California-Riverside, Dundee University's Medical School Archives, the Ottoman Imperial Archives, the Church of Ireland's Representative Church Body Library, Australian War Archives, and many more. These valuable visual resources have been under-utilized by researchers around the world, especially today when many of the collections are digitized online.

I thank and congratulate the librarians and archivists for their foresight and impressive work.

Often I found that photographs were undated, misidentified, or absent of captions. I have published some 500 essays to provide the locations, dates, identification, and background to the pictures. Almost all the photos and essays appear on my website www.israeldailypicture.com. Dozens of my identifications and corrections have been used by libraries to update their captions. I thank the archivists and librarians for their efforts and responses.

Lenny Ben-David,
November 2016

3. Valentine Vester, *The American Colony Family Album,* (Jerusalem: American Colony of Jerusalem, Ltd., 2008).

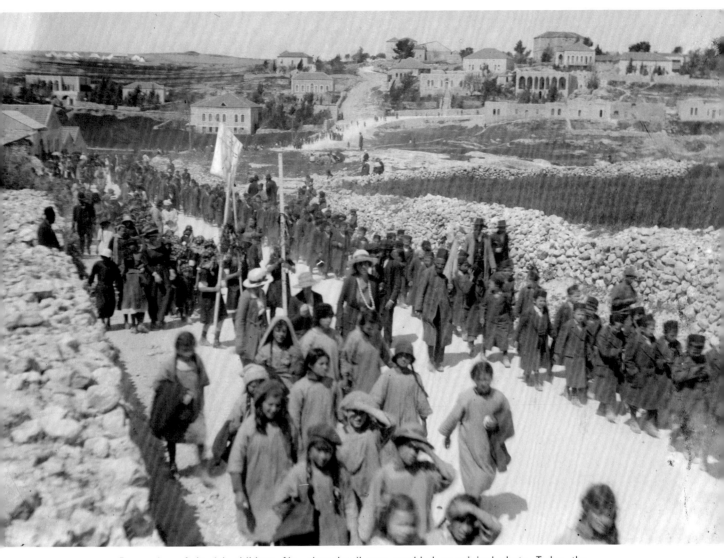

Procession of Jewish children. No other detail was provided on original photo. Today, the caption reads: "Jewish children and adults, one holding a Star of David banner, walking south on Nablus Road towards the grave of Shimon Hatzadik (Simon the Just), Jerusalem." The procession may have taken place on April 30, 1918, the Jewish holiday of Lag Ba'Omer, when visits were traditionally made to the tomb. British (white) army tents in the background (on the left horizon), also suggest the year 1918. L. Ben-David, *Israel's History – A Picture a Day*, circa 1898–1946. (*Library of Congress/American Colony photo*)[ii]

Dedicated to the subjects of the pictures herein for their devotion, bravery, faith, and perseverance – including Ben-Shemen's Jewish children, circa 1930. (*Library of Congress*)

Acknowledgments

I WISH TO THANK MY PUBLISHER, TZVI MAUER, FOR RECOGNIZING THE tremendous educational value these preserved historic photographs provide. I look forward to working with Tzvi on further projects of photographic history books addressing topics such as *Jewish Sites in the Holy Land* and *World War I in the Holy Land*. Thank you, David Ehrlich, for introducing me to Tzvi. Special thanks, as well, go to Martin Oliner for his encouragement and support.

Dr. Michael Oren, Member of Knesset and noted historian, deserves mention for his comprehensive history of American involvement in the Holy Land in *Power, Faith, and Fantasy*, which served as an invaluable reference.

I express my gratitude to my dear, departed parents who instilled in me a passionate love of Zion; to my brother Menachem, a great scholar, editor and advisor; and to my brave sister Marcia who served as the trailblazer to the Land of Israel for our family almost 50 years ago.

I convey my deep love and appreciation to my best friend and wife, Shellie, for her unconditional patience and for tolerating her husband's hobby, which became an obsession and now a book.

I express great admiration for the American public for their strong support of the Jewish homeland over the last two centuries. Some 50 years ago, an Arab-American leader of Israel's detractors proclaimed, "The road to the liberation of Palestine runs through Washington." I want to thank the millions of women and men of all religions and races who work tirelessly to defend and strengthen the Israel-United States relationship in Congress, on campus, and in their public discourse.

Above all, I thank He Who is above all for His bountiful grace and for blessing us with our wonderful children and wondrous grandchildren. Blessed are You Who has given us life and sustained us and brought us to this moment.

Safed, considered one of Judaism's four holy cities. The original "City Built on a Hill," circa 1900. (*Library of Congress, American Colony collection*)

AMERICAN COLONY,
JERUSALEM.

1 Two Shining Cities Built on a Hill

THE LOVE AND DEDICATION AMERICANS HAVE TOWARD THE BIBLE AND the Holy Land predates the formation of the United States. In the New World, the Puritans sought to recreate a new "shining city built on a hill," a phrase quoted by Massachusetts Governor John Winthrop in 1630 from Jesus' Sermon on the Mount,[1] referring to a hill in the Galilee. Colonialists named their children after Old Testament personalities; towns were established with names from the Bible such as Bethlehem, Salem, Jericho, and Hebron; and since 1747, the Hebrew letters of the Jewish Temple's high priest's chest plate, "*Urim V'Tumim – Light and Perfection*," adorned the seal of Yale, one of the earliest American universities.

Historical scholars and researchers have detailed the history of American religious and political leaders' support for the re-creation of a Jewish homeland. I recommend Dr. Michael Oren's masterwork, *Power, Faith, and Fantasy*,[2] to learn of the early American ties to the Middle East.

The love of Zion and the desire for a Jewish homeland has a long history deep in the American nation's DNA. Decades before the creation of the political "Zionist Movement," Americans longed for the re-creation of a Jewish nation in the Holy Land. U.S. President John Adams wrote to a leading Jewish-American figure, Mordecai Manuel Noah, in 1819, ". . . I really wish the Jews again in Judea an independent nation."[3]

The profound relationship between the American people, particularly

1. *Matthew* 5:14.
2. Michael B. Oren, *Power, Faith, and Fantasy: America in the Middle East: 1776 to the Present*, (W.W. Norton & Co, 2007).
3. Mordecai Manuel Noah, *The Selected Writings of Mordecai Noah*, Edited by Michael Joseph Schuldiner and Daniel J. Kleinfeld, (Greenwood Press, 1999). https://books.google.co.il/books?id=Rp7F78jM9kcC&printsec=frontcover#v=onepage&q&f=false

Protestants, and the Holy Land, above all as a home for Jews, underwent a major expansion in the mid-19th century. The "restoration" of Jews to the Biblical Holy Land was believed by many to be a necessary harbinger of the "Second Coming." Two mid-century inventions – the steam ship and photography – enabled Bible believers and tourists to see the Holy Land, either in person or in the form of photographs. As explained by Kathleen Stewart Howe, author of *The Photographic Exploration of Palestine*, tourism encouraged photography, and photographs encouraged tourists.[4]

The precursors of the Christian "Zionist" movement were sometimes imbued with the American belief and expression of the "Manifest Destiny" of the American nation. The combination was clearly evident in the captain's log of Lt. William Lynch of the U.S. Navy who looked eastward after the American-Mexican war and undertook an expedition to explore the Jordan River and the Dead Sea in 1847.[5] Here is an excerpt:

> MAY 18 [1847]. Visited, today, the church of the Holy Sepulcher [in Jerusalem], and other places consecrated by tradition. All these localities have been so repeatedly and so minutely described by other writers, as to be familiar to every Sunday-school scholar, beyond the age of childhood, at home; and Jerusalem itself is, geographically, better known to the educated classes in the United States, than Boston, New York, or Philadelphia, to those who do not reside in and have not visited them.
>
> Neither need anything be said of the present condition and future prospects of Palestine; for it is a theme too copious for this work, even if it were not above the capacity of its author. I can only express an opinion, founded upon what I have seen and heard, that the fanaticism of the Turks is fast subsiding, with the rapid diminution of their number, while the Christian and Jewish population is increasing. As yet, this holds good only of the capital. The country traversed by nomadic tribes, and cultivated but in patches, continues to be as insecure as it is unproductive. But, like the swelling of the waters which precede the tide of flood, there are indications of a favourable change.

4. Kathleen Steward Howe, *Traveling through Bible Lands: The Dream and the Reality (Audio)*, the Getty Iris, June 17, 2011, http://blogs.getty.edu, http://tinyurl.com/j7r4u4x
5. https://en.wikisource.org, http://tinyurl.com/jd9bqyc

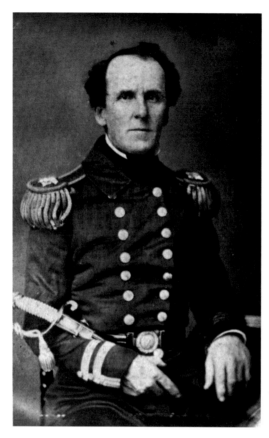

Lt. William Francis Lynch, circa 1850.
(*Naval Historical Center, Photographic Section Collection*)

An illustration from Lt. William Lynch's book. Note the American flag on the boat, 1849. (*Wikimedia*)[i]

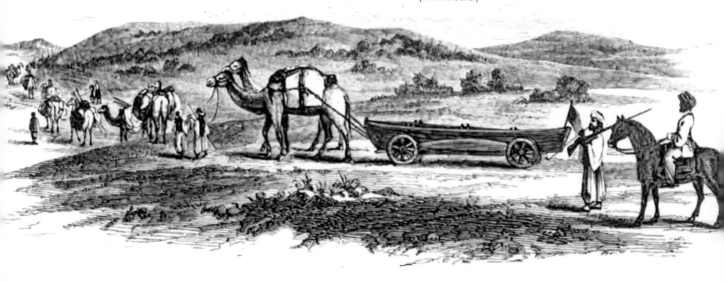

The Muhammedan rule, that political sirocco, which withers all before it, is fast losing the fierce energy which was its peculiar characteristic, and the world is being gradually prepared for the final dismemberment of the Ottoman empire.

Lynch toured the land and not just the waterways. His descriptions of Jewish life in Tiberias provide historians today with surprising details. [See Chapter Two – American "Manifest Destiny" in the Holy Land in 1847.]

American travelogues written in the 1860s and 1870s, such as Mark Twain's *The Innocents Abroad*,[6] Secretary of State William Seward's *Travels around the World*,[7] and President Ulysses S. Grant's *Tour around the World*[8] describe the wretched ruins of the land as well as the presence of Jewish communities throughout Palestine.

British officer Charles Wilson led the *Ordnance Survey of Jerusalem* in 1865 and reported in his log: "It is difficult to obtain statistical information on Jerusalem, but one fact alone will show the unhealthy nature of the city: The Jewish population is estimated at about 9,000, yet in twelve months, more than 13,000 cases of sickness were attended to in their own hospital and that of the Protestant Mission."[9] His Survey was replete with photos of Jerusalem's holy sites, including the Western Wall.

The Library of Congress collection contains photographs of tourists to Jerusalem – maybe Twain's travel colleagues or at least contemporaries – who were possibly photographed by the Wilson expedition's photographer. Both Wilson and Twain's parties were guests in Jerusalem's Mediterranean Hotel.

The bulk of the thousands of photographs from Palestine in the Library of Congress was taken by the American Colony Photographic Department over the course of 50 years, from the 1890s until 1946. The "American Colony" was a group of Christian millennialist utopians who arrived in Jerusalem in

6. Mark Twain, *The Innocents Abroad* (1869), http://classiclit.about.com/library/bl-etexts/mtw ain/bl-mtwain-innocents-56.htm
7. William Henry Seward, *Travels around the World*, 1873, https://www.questia.com/read/982 64370/william-h-seward-s-travels-around-the-world
8. Ulysses S. Grant, https://archive.org , http://tinyurl.com/jgklp9d
9. Charles Wilson, *The Recovery of Jerusalem: A Narrative of Exploration and Discovery in the City and the Holy Land* (1871), Hathi Trust Digital Library, http://babel.hathitrust.org/cgi/pt?id= mdp.39015026722895

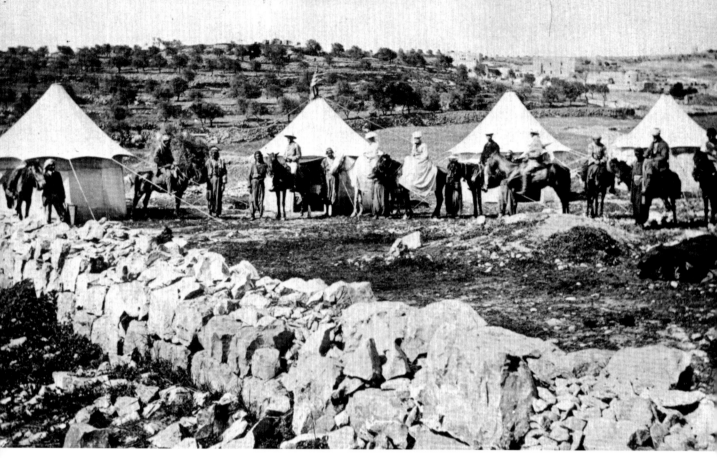

Tourist tents on the outskirts of Jerusalem. Note the American flag on the center tent, circa 1875. (Studio Bonfils, *British Library Endangered Archives Program*)[ii]

1881. The leader of the group, Horatio Spafford, believed that "the return of the Jewish people to Jerusalem was a sign of the imminent second coming of Jesus," according to the Library of Congress curator of a recent exhibit.[10] The American Colony saw as a messianic sign the hundreds of Yemenite Jews who immigrated to Jerusalem in 1882 (see Chapter 10); they were fed and sheltered by the Americans.

10. Library of Congress Prints and Photographs Division, Washington, DC, http://www.loc.gov/exhibits/americancolony/amcolony-jerusalem.html

Countering historical distortions

The ongoing delegitimization campaign against Israel and the Jewish state takes many forms – militarily, diplomatically, and through the media. If the Holocaust can be denied by anti-Semites, the history of the Jewish people and their bond with the Land of Israel can also be denied by Israel's enemies. For example, Yasser Arafat declared at the Camp David talks that no Jewish Temple had ever existed in Jerusalem. Likewise, while addressing the UN General Assembly in New York on September 25, 2012, Iranian president Mahmoud Ahmadinejad told reporters that the "Zionist state" had "no roots" in the Middle East and would be "eliminated."[11]

The claim that Israel was founded only in 1948 and as the world's response to the Holocaust is a common misperception and propaganda refrain. "Americans and Europeans exported the conflict created by Hitler to our land," said Essam El-Erian, a senior member of Egypt's Muslim Brotherhood in 2011. "Why do the Palestinians pay the price of Nazis?"[12] President Barack Obama reinforced this misperception in his well-meaning but misplaced reference to Jewish history in his June 4, 2009, Cairo speech: "[T]he aspiration for a Jewish homeland is rooted in a tragic history that cannot be denied. Around the world, the Jewish people were persecuted for centuries, and anti-Semitism in Europe culminated in an unprecedented Holocaust. . . ." The president then presented an "evenhanded" equivalent: "On the other hand, it is also undeniable that the Palestinian people – Muslims and Christians – have suffered in pursuit of a homeland. For more than sixty years they have endured the pain of dislocation. . . ."[13]

These statements are basically inaccurate and fail to acknowledge the continuous historical presence of Jews in the Holy Land dating from ancient times. Historical photographs provide visual evidence of the past 160 years.

In today's media environment of quick sound bites, brief news cycles,

11. Yitzhak Benhorin, "Ahmadinejad: Israel has no roots in Middle East," Ynet News, September 24, 2012, http://www.ynetnews.com/articles/0,7340,L-4285579,00.html

12. Yitzhak Benhorin, "Palestinians paying for Nazi crimes," Ynet News, May 14, 2011, http://www.ynetnews.com/articles/0,7340,L-4068520,00.html.

13. Barack Obama, Speech in Cairo, "A New Beginning," June 4, 2009, http://www.whitehouse.gov/blog/NewBeginning/transcripts

Facebook, and 140-character Tweets, presenting Israel's history and beating back attempts at delegitimization can be well served by presenting the treasure trove of century-old photos such as those of the American Colony, the Ottoman Empire Archives, the British Library, the New York Public Library, Harvard University, the Central Zionist Archives, a little church in Ireland, the medical archives in the University of Dundee, or even a collection of old photos from Grandma's attic.

In 2011, boxes of "lantern slides" from 1897 were found in the old Church of Ireland Killaloe deanery in Limerick. Dr. Susan Hood, the archivist for the Church of Ireland's Representative Church Body Library, digitized the treasures and permitted the author to publicize them.

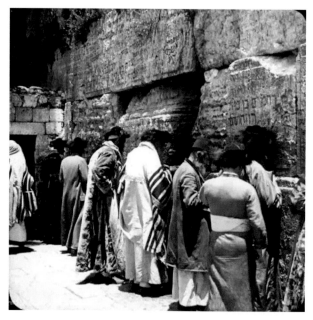

Jews praying at the Western "Wailing" Wall. The day appears to be a Sabbath or Jewish Festival, since the men are wearing their Sabbath finery, including fur hats. The photograph is unusual since in nearly all other 19th century pictures at the Wall, men are not wearing their customary prayer shawls (*talit*) perhaps because of a Jewish prohibition of carrying objects on the Sabbath or because of the harassment of Muslim authorities. (*Credit: RCB Library,* 1897)

2 American "Manifest Destiny" in the Holy Land in 1847

WILLIAM FRANCIS LYNCH (1801–1865) WAS A NAVAL OFFICER who served in both the U.S. Navy and the Confederate Navy. In the 1840s, he proposed to the United States Government to undertake a voyage to the Holy Land to explore and map the Jordan River and the Dead Sea.

In 1847, Lynch conducted his mission with a crew of 16 sailors and published his findings in his book, *Narrative of the United States' Expedition to the River Jordan and the Dead Sea*.[1] Lynch did not include a photographer in his entourage, but a crewman did provide illustrations for his book.

Lynch's motives appeared to be patriotic, religious, and scientific. He wrote, "We [Americans] owe something to the scientific and Christian world, and while extending the blessing of civil liberty in the south and west [otherwise known as "Manifest Destiny"], may well afford to foster science and strengthen the bulwarks of Christianity in the east."

Lynch was also a strong adherent of "restorationism" (a precursor to Christian Zionism) – a belief that the Jewish people must return to the Holy Land to fulfill their biblical prophecy of the "Second Coming." This belief drove some Americans, including American presidents, to advocate for the establishment of a Jewish homeland.

Along the route, Lynch described raging rapids in the Jordan River, difficult terrain, strange flora and fauna, warring Arab tribes, and suffering Christian and Jewish communities.

1. Lt. William Francis Lynch, U.S. Navy, *Narrative of the United States' Expedition to the River Jordan and the Dead Sea*, https://en.wikisource.org , http://tinyurl.com/jfxkwjz

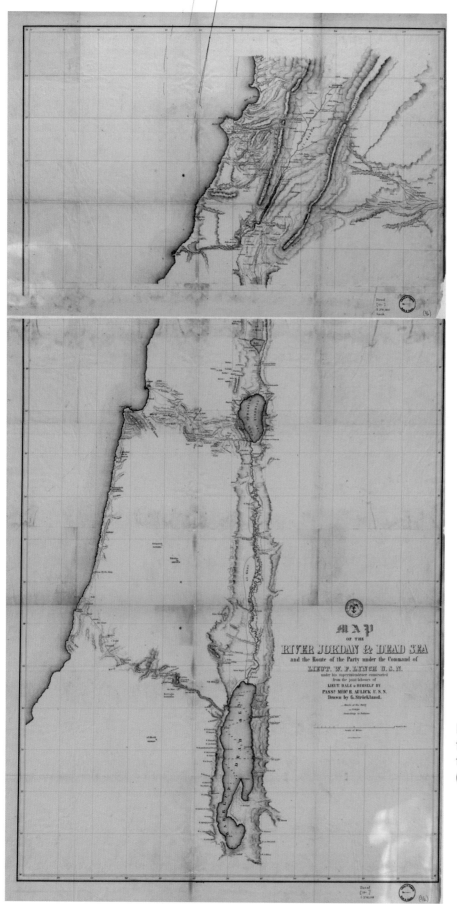

Map of Lynch's journey
from the Sea of Galilee to
the Dead Sea, 1847.
(*World Digital Library*)[i]

Below is Lynch's remarkable description of the Jews of Tiberias from 1847. He writes that the community was 1,000-strong and led by a "Sanhedrin" of rabbis. This detail is quite remarkable as Jewish sages from Safed and Jerusalem furiously debated in the 1500s whether to reestablish the Sanhedrin of the Temple period. As far as we know, they did not, and no known Sanhedrin has been convened to this day.

Lynch: *Safed and Tiberias, Jerusalem and Hebron, are the four holy cities of the Jews in Palestine. Tiberias is held in peculiar veneration by the Jews, for here they believe that Jacob resided, and it is situated on the shores of the lake whence the Jews hope that the Messiah will arise.*

Winding down the rugged road, we descended to the city, seated on the margin of the lake. Tiberias (Tubariyeh) is a walled town of some magnitude, but in ruins, from the earthquake which, in 1837, destroyed so many of its inhabitants.

We had letters to the chief rabbi of the Jews, who came to meet us, and escorted us through labyrinthine streets to the house of Heim Wiseman, a brother Israelite. It is a hotel sui generis, as well in the mode of entertaining as in the subsequent settlement with its guests. . . .

A trifling circumstance will show in what thraldom the Jews are held. Our landlord, Heim Wiseman, had been kind enough to show me the way to the governor's. On our entrance, he meekly sat down on the floor, some distance from the divan. After the sherbet was handed round to all, including many Arabs, it was tendered to him. It was a rigid fast-day with his tribe, the eve of the feast of the azymes [unleaved bread, i.e. Passover], and he declined it. It was again tendered, and again declined, when the attendant made some exclamation, which reached the ears of the governor, who thereupon turned abruptly round, and sharply called out, "Drink it." The poor Jew, agitated and trembling, carried it to his lips, where he held it for a moment, when, perceiving the attention of the governor to be diverted, he put down the untasted goblet.

The Jews here are divested of that spirit of trade which is everywhere else their peculiar characteristic. Their sole occupation, we were told, is to pray and to read the Talmud. That book, Johann Ludwig Burckhardt says, declares that creation will return to primitive chaos if prayers are not addressed to

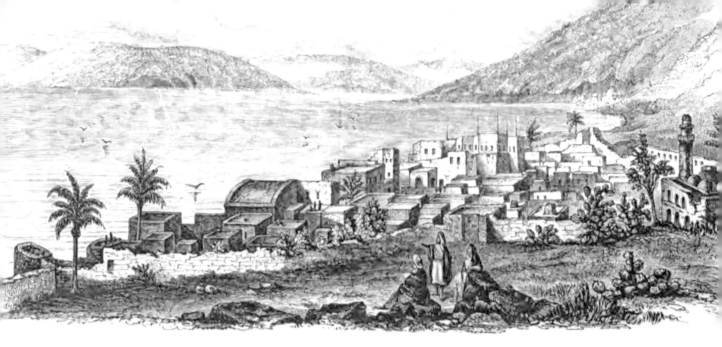

Illustration of Tiberias in Lynch's book. (*Wikisource*)[ii]

the God of Israel at least twice a week in the four holy cities. Hence the Jews all over the world are liberal in their contributions.

Returned the visit of the Rabbis. They have two synagogues, the Sephardim and Ashkenazim, but live harmoniously together. There are many Polish Jews, with light complexions, among them. They describe themselves as very poor, and maintained by the charitable contributions of Jews abroad, mostly in Europe. More meek, subdued, and unpretending men than these Rabbis I have never seen. . . .

Details on the synagogue and a historical surprise

In the evening we visited several of the synagogues. It was impressive yet melancholy to witness the fervid zeal of the worshippers. In gabardines, with broad and narrow phylacteries [probably prayershawls, and not tephillin], some of them embroidered, the men were reading or rather chant-ing, or rather screaming and shouting, the lamentations of Jeremias — all the time swaying their bodies to and fro with a regular and monotonous movement. There was an earnest expression of countenance that could not have been feigned. The tones of the men were loud and almost querulous

with complaint; while the women, who stood apart, were more hushed in their sorrow, and lowly wailed, moving the heart by their sincerity. In each synagogue was an octagon recess, where the Pentateuch and other sacred works were kept. Whatever they may be in worldly matters, the Jews are no hypocrites in the article of faith.

There are about three hundred families, or one thousand Jews, in this town. The Sanhedrin consists of seventy rabbis, of whom thirty are natives and forty Franks, mostly from Poland, with a few from Spain. The rabbis stated that controversial matters of discipline among Jews, all over the world, are referred to this Sanhedrin.

It needs but the destruction of that power which, for so many centuries, has rested like an incubus upon the eastern world, **to ensure the restoration of the Jews to Palestine. The increase of toleration; the assimilation of creeds; the unanimity with which all works of charity are undertaken, prove, to the observing mind, that, ere long, with every other vestige of bigotry, the prejudices against this unhappy race will be obliterated by a noble and a God-like sympathy . . . the time will come. All things are onward; and, in God's providence, all things are good. How eventful, yet how fearful, is the history of this people! The Almighty, moved by their lamentations, determined, not only to relieve them from Egyptian bondage, but to make them the chosen depositary of his law.** [emphasis added]

3　The Secret Identity of American Preacher Mendenhall John Dennis (AKA Mendel Diness of Jerusalem)

N 1988, JOHN BARNIER VISITED A GARAGE SALE IN ST. PAUL, MINNESOTA. There, he found and purchased eight boxes of old photographic glass plates. Fortunately, Barnier is an expert in the history of photographic printing.

He had little idea that he had uncovered a historic treasure. Later, he viewed the plates and saw that they included old pictures of Jerusalem. He contacted the Harvard Semitic Museum in Cambridge, Massachusetts, known for its large collection of old photographs from the Middle East.

On some of the plates they found the initials MJD. Until then the name Mendel Diness was barely known by scholars. It was assumed that, with the exception of a few photos, his collection was lost.

Thanks to the research of historians and curators Dror Wahrman, Nitza Rosovsky, and Carney Gavin, the Diness collection was saved from obscurity, and an amazing tale was revealed: American Christian preacher Mendenhall John Dennis and Jerusalemite yeshiva student and watchmaker Mendel Diness were identified as one and the same.

Diness was born in Odessa in 1827 into a religious Jewish family. As a boy, he apprenticed as a watchmaker; as a teen, he went to study in Heidelberg and was influenced by the anti-religious "Enlightenment movement." His concerned father sent him to Palestine in 1848 to a yeshiva to strengthen his Jewish faith.

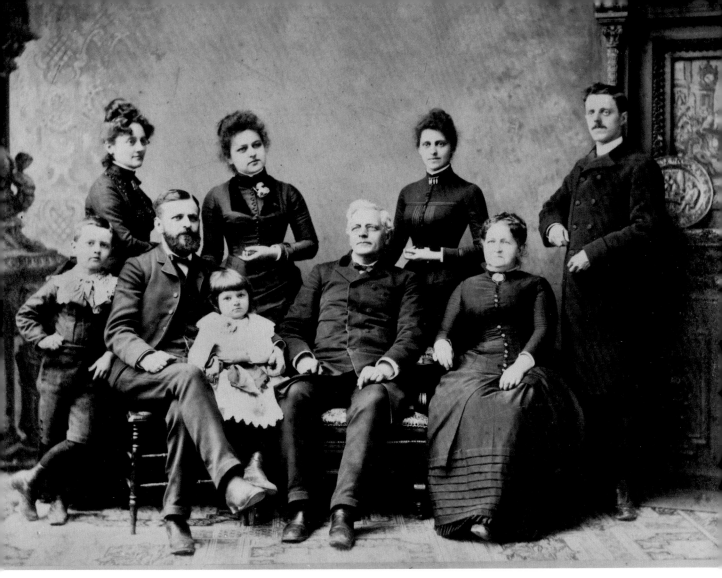

Preacher Mendenhall John Dennis in the center surrounded by his family in 1885. After 1860, he lived in Ohio, Massachusetts, and Washington State. Before 1860 his name was Mendel Diness of Jerusalem. (*Special Collections, Fine Arts Library, Harvard University*)[i]

But in 1849 he met a Christian missionary who got him started on his path to Christianity. His conversion caused a major controversy in the Old City of Jerusalem. Diness was excommunicated from the Jewish community, lost his business, and was forced to divorce his wife, Shayndel Reisa, who was from a Hassidic Chabad family in Hebron.

Diness was taken in by Christian missionaries and families, including the British Consul, James Finn, who baptized the new convert. Scottish missionary, James Graham, a close acquaintance of James Finn's wife, Elizabeth Finn,

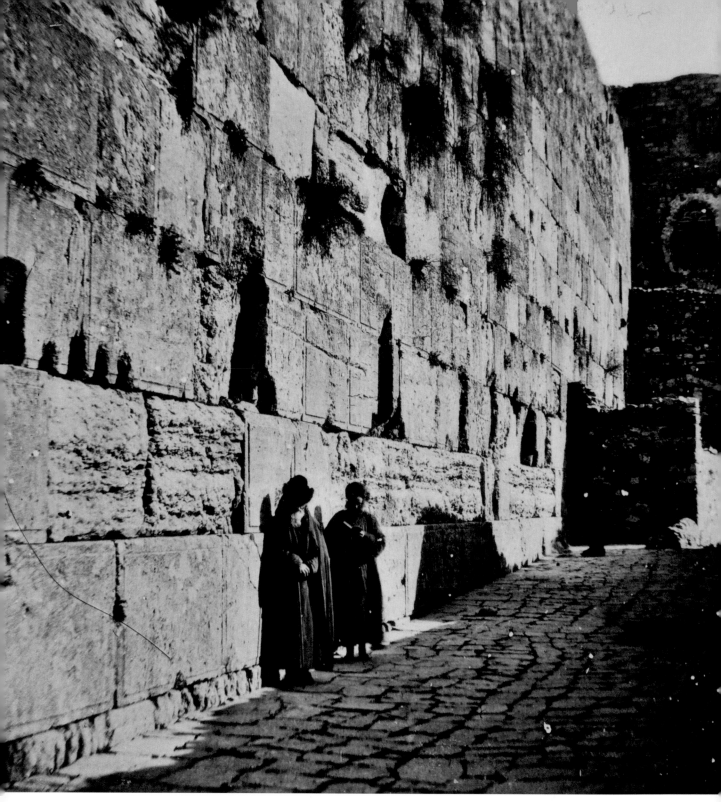

Perhaps one of the first photographs of Jews at the Western Wall, photographed by Diness, 1859.
(*Special Collections, Fine Arts Library, Harvard University*)

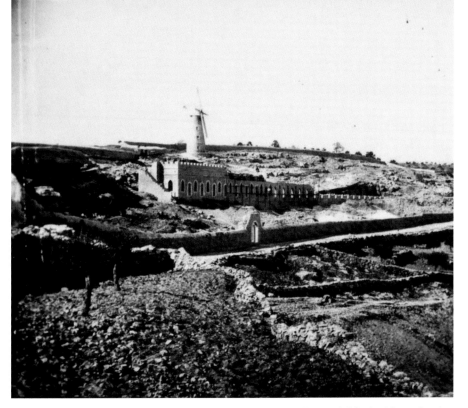

Mishkenot Sha'ananim in Jerusalem under construction, beneath Moshe Montefiore's windmill. The building project was the first Jewish neighborhood built outside of the Old City, 1860. (*Special Collections, Fine Arts Library, Harvard University*)

taught Diness the new field of photography. It was not simply a question of learning to press a button on a camera, but it involved a lengthy and difficult process of preparing emulsions and plates (not film), mastering light, exposures, and the science of developing the pictures.

By 1856, Mendel Diness was photographing on his own. By the end of the decade, however, other photographers had flocked to Jerusalem, and Diness found the competition daunting. In 1861, he moved to the United States with his new wife, the daughter of a Jewish doctor who had converted to Christianity. Diness was unsuccessful as a photographer in Cincinnati, Ohio and became a peripatetic Evangelical preacher, renamed Mendenhall John Dennis.[1] He died in Port Townsend, Washington, on December 1, 1900.

How did the Dennis/Diness collection end up in St. Paul? Following his death in 1900, Mendel Diness' belongings were apparently sent to his

1. Piney Kesting, *The Diness Discovery* (*Aramco World*, July/August 2004), http://archive.aram coworld.com/issue/200404/the.diness.discovery.htm

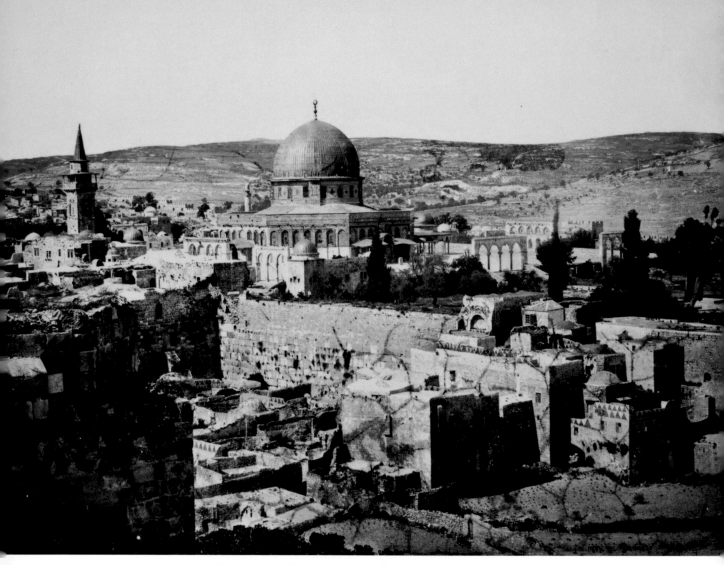

Picture of the Temple Mount and Western Wall by Diness, 1859.
(*Special Collections, Fine Arts Library, Harvard University*)

daughter in New Jersey. When *her* daughter died (Mendel Diness' grand-
daughter), a grandson cleaned out her attic and brought the crates to Min-
nesota. The family was unaware of their ancestor Dennis/Diness and his
rich Jerusalem photography background.

Above is another photograph from Mendel Diness' collection (*Special
Collections, Fine Arts Library, Harvard University*).

4 What Lincoln Would Have Seen in Jerusalem

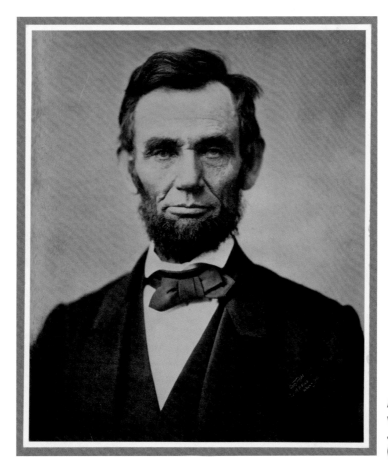

Abraham Lincoln, would-be pilgrim to Jerusalem, 1863. (*Library of Congress*)

P RESIDENT ABRAHAM LINCOLN WAS ASSASSINATED IN FORD'S THEATRE in Washington, D.C., on April 15, 1865. Days later, Lincoln's widow, Mary Todd Lincoln, told the Springfield, Ill. pastor who presided at Abraham Lincoln's funeral that her husband "wanted to visit the Holy Land and see those places hallowed by the footprints of the

Saviour. . . . He was saying there was no city he so much desired to see as Jerusalem."[1]

Where did Lincoln get the idea to travel to Jerusalem?

Lincoln's Secretary of State William H. Seward visited Jerusalem in 1859 and probably recounted to his friend, the President, what he saw. Seward returned to Palestine a second time in 1871.

Seward wrote a fascinating account of his second visit.[2] He described and detailed the demographics of Jerusalem's residents by religion, his visit to the "Wailing Place of the Jews" [also known as the Western Wall or the Kotel] and joining Friday night services at the Hurva Synagogue in the Old City.[3]

Recently digitalized photos from the Library of Congress Archives show,

1. William Johnstone, *How Lincoln Prayed*, 1931, Abingdon Press, e-book, https://archive.org/stream/howlincolnprayed00john/howlincolnprayed00john_djvu.txt

2. William H. Seward, *Travels around the World*, Olive Risley Seward, Editor, 1873. E-book https://www.questia.com/read/98263730/william-h-seward-s-travels-around-the-world

3. William H. Seward, *Travels around the World*, Olive Risley Seward, Editor, 1873. E-book https://www.questia.com/read/98263730/william-h-seward-s-travels-around-the-world. Seward's description of Friday evening prayers in Jerusalem: Excerpt from Seward's *Travels around the World*:

 Directly in the center of the room, between the door and this platform, is a dais six feet high and ten feet square, surrounded by a brass railing, carpeted; and containing cushioned seats. We assume that this dais, high above the heads of the worshippers, and on the same elevation with the platform appropriated to prayer, is assigned to the rabbis. We took seats on one of the benches against the wall; presently an elderly person, speaking English imperfectly, invited Mr. Seward to change his seat; he hesitated, but, on being informed by Mr. Finkelstein that the person who gave the invitation was the president of the synagogue, Mr. Seward rose, and the whole party, accompanying him, were conducted up the steps and were comfortably seated on the dais, in the "chief seat in the synagogue." On this dais was a tall, branching, silver candlestick with seven arms.

 The congregation now gathered in, the women filling the gallery, and the men, in varied costumes, and wearing hats of all shapes and colors, sitting or standing as they pleased. The lighting of many silver lamps, judiciously arranged, gave notice that the sixth day's sun had set, and that the holy day had begun. Instantly, the worshippers, all standing, and as many as could turning to the wall, began the utterance of prayer, bending backward and forward, repeating the words in a chanting tone, which each read from a book, in a low voice like the reciting of prayers after the clergyman in the Episcopal service. It seemed to us a service without prescribed form or order. When it had continued some time, thinking that Mr. Seward might be impatient to leave, the chief men requested that he would remain a few moments, until a prayer should be offered for the President of the United States, and another for himself. Now a remarkable rabbi, clad in a long, rich, flowing sacerdotal dress, walked up the aisle; a table was lifted from the floor to the platform, and, by a steep ladder which was held by two assistant priests, the rabbi ascended the platform. A large folio Hebrew manuscript was laid on the table before him. . . .

William H. Seward, Secretary of State, world traveler, circa 1865. (*Library of Congress*)[i]

At the close of the reading, the rabbi came to Mr. Seward and informed him that it was a prayer for the President of the United States, and a thanksgiving for the deliverance of the Union from its rebellious assailants. Then came a second; it was in Hebrew and intoned, but the rabbi informed us that it was a prayer of gratitude for Mr. Seward's visit to the Jews at Jerusalem, for his health, for his safe return to his native land, and a long, happy life. The rabbi now descended, and it was evident that the service was at an end.

in exceptional detail, what Lincoln would have seen of the Western Wall of the Temple Mount in 1865.

In his travelogue, Seward reported on important demographic details relating to the Jewish community of Jerusalem in 1871:

> *The population of Palestine is estimated at only 200,000. . . . Jerusalem is divided now according to its different classes of population. The Mohammedans are four thousand, and occupy the northeast quarter, including the whole area of the Mosque of Omar. The Jews are eight thousand; and have the southeast quarter. . . . The Armenians number eighteen hundred, and have the southwest quarter and the other Christians, amounting to twenty-two hundred, have the northwest quarter.*
>
> *For centuries (we do not know how many) the Turkish rulers have allowed the oppressed and exiled Jews the privilege of gathering at the foot of this [wailing] wall one day in every week, and pouring out their lamentations over the fall of their beloved city, and praying for its restoration to the Lord . . . The Jewish Sabbath being on Saturday, and beginning on Friday, the weekly wail of the Jews under the wall takes place on Friday.*

Seward revealed a heart-wrenching story of an American Jewish family he met on his ship:

> *As we sat on the deck of our steamer, coming from Alexandria to Jaffa, we remarked a family whom we supposed to be Germans. It consisted of a plainly-dressed man, with a wife who was ill, and two children – one of them an infant in its cradle. The sufferings of the sick woman, and her effort to maintain a cheerful hope, interested us. The husband, seeing this, addressed us in English. Mr. Seward asked if he were an English-man. He answered that he was an American Jew, that he had come from New Orleans, and was going to Jerusalem. We parted with them on the steamer. The day after we reached the Holy City we learned that the poor woman had climbed the mountain with her husband and children, and arrived the day after us. She died immediately, and so achieved the design of her pilgrimage. She was buried in this cemetery. She was a Jewess, and, according to the Jewish*

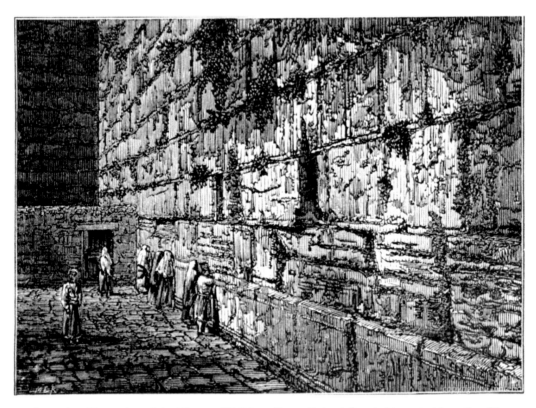

A woodcut illustration of the Western Wall from Seward's book,[ii] probably copied from the 1865 photograph that appears at the end of this chapter.

interpretation of the prophecies, the Jew that dies in Jerusalem will certainly rise in paradise.

Following is the high resolution photograph of the Kotel taken by Peter Bergheim (1813–1875), one of the first resident photographers in the Holy Land. This is the photograph from which the Seward woodcut may have been copied. It is among the earliest photographs taken at the "Kotel."

A converted Jew, Bergheim was well aware of the holy sites of Jerusalem. He set up a photography studio in the Christian Quarter of Jerusalem; his family owned a bank inside the Jaffa Gate.

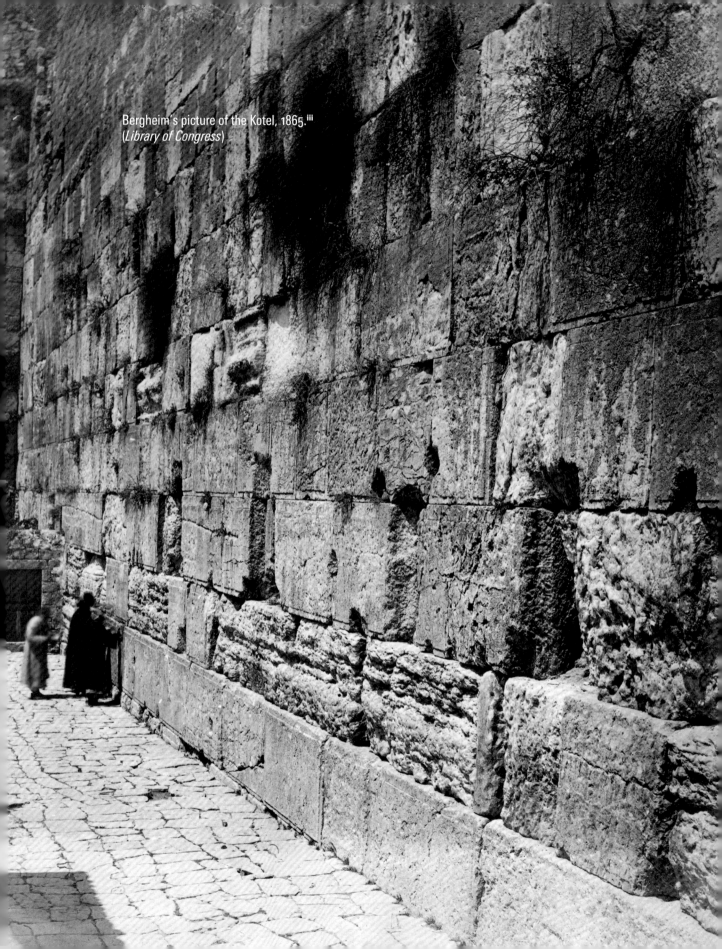

Bergheim's picture of the Kotel, 1865.[iii]
(*Library of Congress*)

5 The Humbugged American Colony in Jaffa

T HE SECOND HALF OF THE 19TH CENTURY SAW MANY MISSIONARIES, adventurers, and tourists from the United States visiting the Holy Land. One eccentric missionary was George Jones Adams of Maine who brought his flock of followers and attempted to establish an "American Colony" in Jaffa. He failed miserably, even at one point appealing to American government officials and the Governor of Maine, Civil War hero Joshua Chamberlain, for assistance.

Two contemporary writers described Adams and his colony. One was an extraordinary writer and actress from Jerusalem, Madam Lydia Mamreoff Von Finkelstein Mountford (1855–1917), whose clippings were discovered in a New Zealand archive. (See Chapter 12 – Madam Lydia, Diva of the Holy Land.) The other writer was American humorist Mark Twain. He met some of the colony's survivors on his ship returning from his "Innocents Abroad" voyage in 1867 and described their travails.

According to Madam Von Finkelstein – *In the year 1866 a large American colony came out, and settled in Jaffa. It was called the American Adams colony. The colonists held their estate under great disadvantages. Mr. Adams, either through design or in ignorance of the laws, possessed no title deeds; neither were the colonists, who purchased lots, provided with the necessary documents — all holding the property under bills of sale and purchase, whose legality and validity could have been questioned at any moment. Consequently interested parties took advantage of their position, and the best and the largest portion of the land they had paid for was lost, and all the trees out of a fruit plantation cut down, rooted up, and carried away because they*

The colony founder, George Jones Adams, circa 1841. (*Library of Congress*)

whose duty it was to protect the colonists against such legalised frauds, either from interested motives or through gross negligence, omitted to secure for the purchasers the title deeds, which documents also were only rendered legal under certain conditions.

Foreigners, or their agents, should be thoroughly acquainted with what perhaps at the first may seem to be the minor details of the laws of purchase and tenure before they buy real estate in Syria or Palestine; otherwise they run a risk of paying the price many times over in bribes and lawsuits to substantiate their claims. The several American colonies proved failures through a number of causes, jealousies of and ill-will towards such enterprises existing in many quarters.

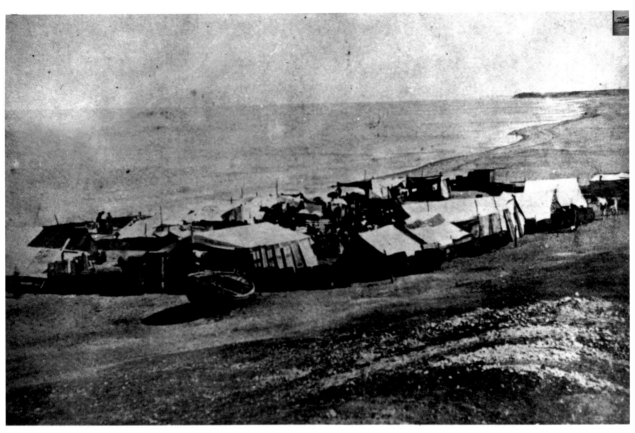

The American Colony encampment on the sea shore near Jaffa, 1866. (*with permission of the Maine Historical Society*)[i]

First, the Ottoman Government never was, nor is it at the present day [1888], capable of appreciating the motives of foreigners in colonisation, and cannot see, any reason, beyond a political one, for the settlement of Europeans or Americans in the country. Secondly, besides having in the local authorities a positively hostile government to struggle against, the colonists received no proper support from their consular representatives, a circumstance perfectly well known to the native and other residents, who were not slow to avail themselves of the opportunities thus afforded them, not only to encroach on the rights of the colonists, but to overreach and wrong them in all transactions, great or small. Thirdly, the difficulties of colonists have always been increased by the jealousies of the Latin Convents. . . . Aroha

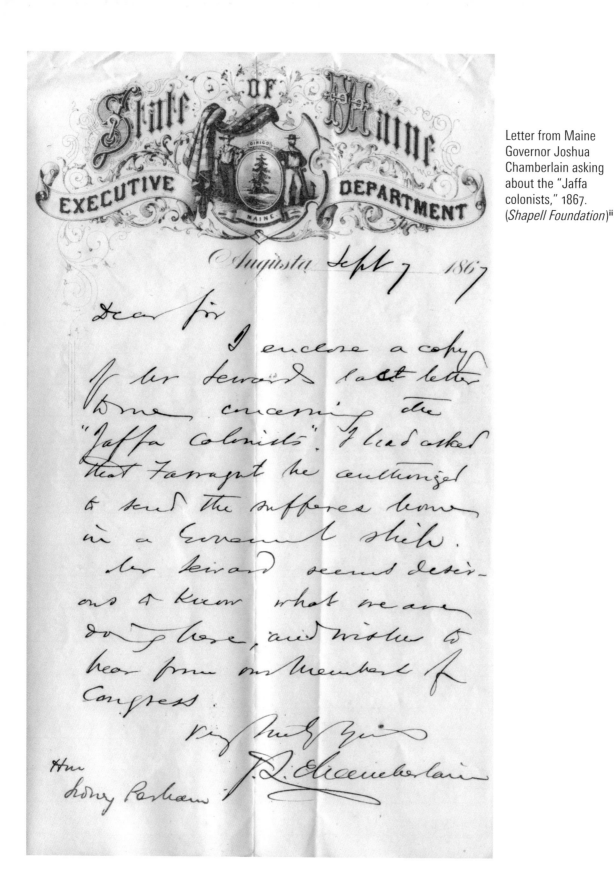

STATE OF MAINE

EXECUTIVE DEPARTMENT

Augusta Sept 7 1867

Dear Sir

I enclose a copy
of Mr Seward last letter
to me, concerning the
"Jaffa colonists". I had asked
that Farragut be authorized
to send the sufferers home
in a Government ship.

Mr Seward seemd desir-
ous to know what we are
doing here, and wishes to
hear from our Members of
Congress.

Very truly Yours

J. L. Chamberlain

Hon
Sidney Perham

Letter from Maine Governor Joshua Chamberlain asking about the "Jaffa colonists," 1867. (*Shapell Foundation*)[ii]

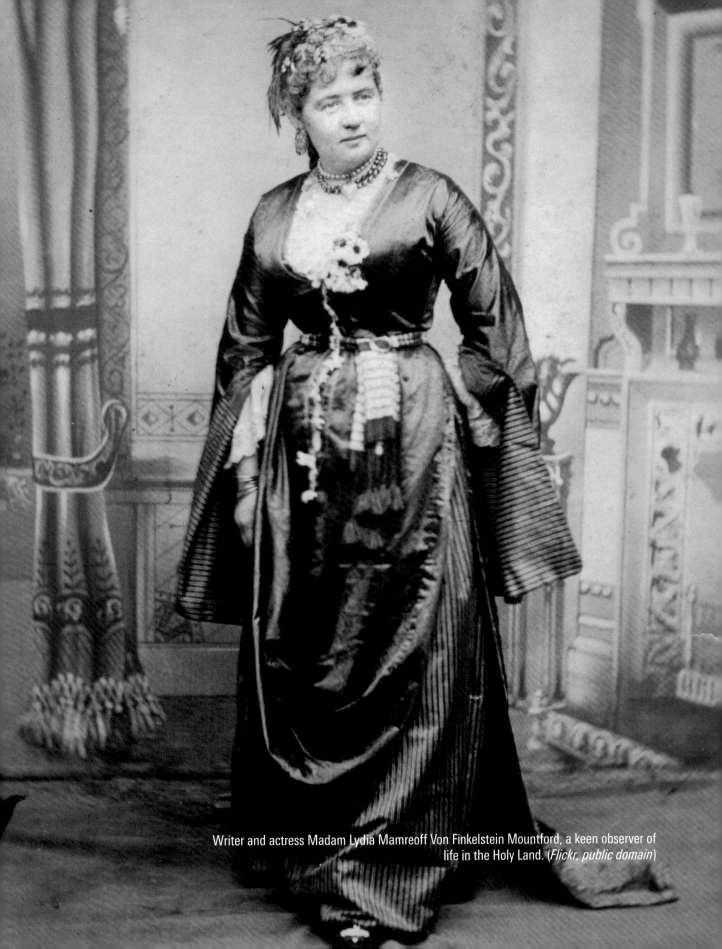

Writer and actress Madam Lydia Mamreoff Von Finkelstein Mountford, a keen observer of life in the Holy Land. (*Flickr, public domain*)

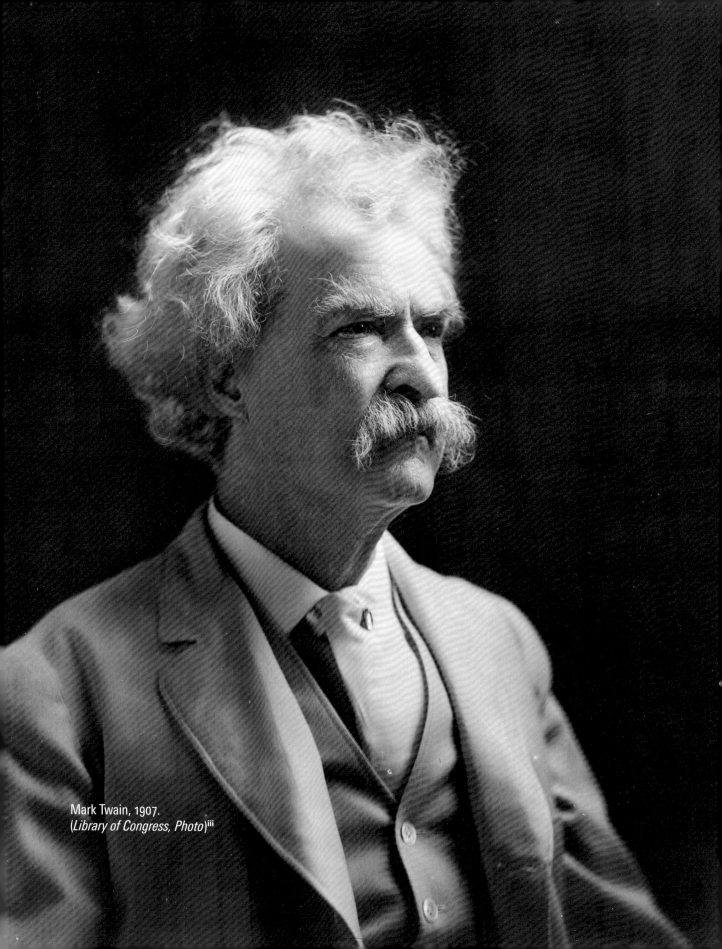

Mark Twain, 1907.
(*Library of Congress, Photo*)[iii]

News (New Zealand), October 24, 1888, "Palestine Fifty Years Ago and Palestine Today."[1]

According to Mark Twain – . . . *But I am forgetting the Jaffa Colonists. At Jaffa we had taken on board some forty members of a very celebrated community. They were male and female; babies, young boys and young girls; young married people, and some who had passed a shade beyond the prime of life. I refer to the "Adams Jaffa Colony." Others had deserted before. We left in Jaffa Mr. Adams, his wife, and fifteen unfortunates who not only had no money but did not know where to turn or whither to go. Such was the statement made to us.*

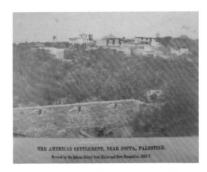

The American Colony near Jaffa, 1866–7. (*Library of Congress*)

The colony was a complete fiasco. I have already said that such as could get away did so, from time to time. The prophet Adams – once an actor, then several other things, afterward a Mormon and a missionary, always an adventurer – remains at Jaffa with his handful of sorrowful subjects.

Our forty were miserable enough in the first place, and they lay about the decks seasick all the voyage, which about completed their misery, I take it. However, one or two young men remained upright, and by constant persecution we wormed out of them some little information. They gave it reluctantly and in a very fragmentary condition, for, having been shamefully humbugged by their prophet, they felt humiliated and unhappy. In such circumstances people do not like to talk.[2]

1. Lydia Von Finkelstein, "Palestine 50 Years Ago and Palestine Today" (*Te Aroha News*, October 24, 1888), Papers Past, New Zealand National Library, http://paperspast.natlib.govt , 1, http://tinyurl.com/zqzxuq5
2. Mark Twain, *The Innocents Abroad*, Chapter 57, http://genius.com/Mark-twain-the-innocents-abroad-chap-57-annotated

6 Mark Twain in the Holy Land in 1867 with the "Innocents Abroad"

Mark Twain, aka Samuel Clemens, was a relatively unknown writer in 1867 when he visited Palestine in the company of 64 "pilgrims and sinners" and wrote these words:

Palestine sits in sackcloth and ashes. Over it broods the spell of a curse that has withered its fields and fettered its energies. . . . Renowned Jerusalem itself, the stateliest name in history, has lost all its ancient grandeur, and is become a pauper village; the riches of Solomon are no longer there to compel the admiration of visiting Oriental queens; the wonderful temple which was the pride and the glory of Israel, is gone, and the Ottoman crescent is lifted above the spot where, on that most memorable day in the annals of the world, they reared the Holy Cross.

The Innocents Abroad, Twain's best-selling book chronicling his travels through Europe and the Holy Land in 1867, established him as a great American writer. His vivid, iconoclastic, satiric, and often depressing descriptions of the Holy Land are also an important historical testimony.

Two pictures contained in the Library of Congress collection depict "tourist" pilgrims around the time of Twain's visit. Could these pictures be a *photographic* testimony of Twain's visit? Twain's party stayed at the Mediterranean Hotel in Jerusalem's Old City at the same time as the 1867 British expedition of the Palestine Exploration Fund led by Charles Warren.

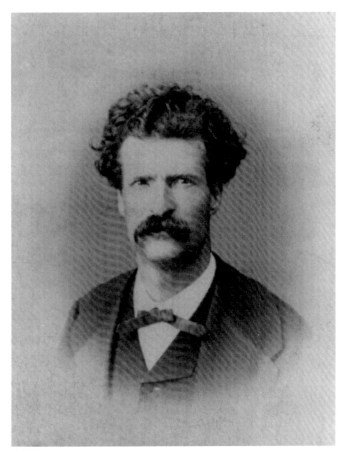

"Samuel Langhorne Clemens, aka Mark Twain." The photo was taken in Constantinople during his voyage, 1867. (*Library of Congress*)[i]

Could the photos of the Jerusalem "tourists" at the Old City wall have been taken by Warren's photographer, Corporal Henry Phillips?[1]

Corporal Henry Phillips' two pictures of seven "German Jews" (page 56) and seven "Polish Jews" (page 57) were photographed in Jerusalem. (They were the same men, some of whom were probably models.) The numbered board on the wall behind them was the Mediterranean Hotel's key holder – the same hotel where Twain's party stayed.

Additional circumstantial evidence of the photos showing members

1. Captain Charles W. Wilson, *Ordnance Survey of Jerusalem*, 1865. (New York Public Library Digital Collections) http://digitalcollections.nypl.org/items/510d47d9-645e-a3d9-e040-e0 0a18064a99/book?parent=9de385a0-c6cb-012f-206b-58d385a7bc34#page/1/mode/2up

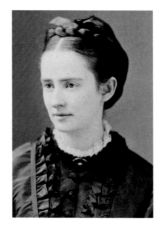

On left, Olivia Langdon Twain, 1867. (*University of California Press*).[ii] On right, close-up of unnamed tourist from photos on following pages.

of Twain's party is seen in the almost identical dresses worn in 1867 by Twain's wife, Olivia,[2] who was not on the trip, and the unknown "tourist" in the Library of Congress photograph. Consultations with experts at the Mark Twain Project at the University of California at Berkeley, including comparing known photographs of "Innocents," have not found matches yet.

Quotations from *The Innocents Abroad*[3]

On Jerusalem

> *It seems to me that all the races and colors and tongues of the earth must be represented among the fourteen thousand souls that dwell in Jerusalem. Rags, wretchedness, poverty and dirt, those signs and symbols that indicate the presence of Moslem rule more surely than the crescent-flag itself, abound. Close by is the Golden Gate, in the Temple wall – a gate that was an elegant piece of sculpture in the time of the Temple, and is even so yet. From it, in ancient times, the Jewish High Priest turned loose the scapegoat and let him*

2. Photograph of Olivia (Livy) Langdon, *This Is Mark Twain*, http://www.thisismarktwain.com/timeline/1867.html
3. Mark Twain, *The Innocents Abroad*, or *The New Pilgrims' Progress*, http://classiclit.about.com/library/bl-etexts/mtwain/bl-mtwain-innocents-56.htm

flee to the wilderness and bear away his twelve-month load of the sins of the people. If they were to turn one loose now, he would not get as far as the Garden of Gethsemane, till these miserable vagabonds here would gobble him up. . . .

A fast walker could go outside the walls of Jerusalem and walk entirely around the city in an hour. I do not know how else to make one understand how small it is.

On the land of Palestine

Of all the lands there are for dismal scenery, I think Palestine must be the prince. The hills are barren, they are dull of color, they are unpicturesque in shape. The valleys are unsightly deserts fringed with a feeble vegetation that has an expression about it of being sorrowful and despondent. . . . Palestine sits in sackcloth and ashes. Over it broods the spell of a curse that has withered its fields and fettered its energies. . . .

Palestine is desolate and unlovely. And why should it be otherwise? Can the curse of the Deity beautify a land? Palestine is no more of this work-day world. It is sacred to poetry and tradition – it is dream-land.

Twain's guide in his Middle East sojourn was a man he named "Far-Away-Moses."[4] Moses shows up in our survey of American connections 30 years later. (See Chapter 11 – Bringing the Holy Land to America, Together with Mark Twain's Guide.)

4. Far Away Moses / Jew: 1893 Ethnic Portrait, World's Columbian Exposition Chicago, *Portrait Types of the Midway Plaisance; published in 1894 by N. D. Thompson, St. Louis*, https://www.loc.gov/resource/cph.3c04678/

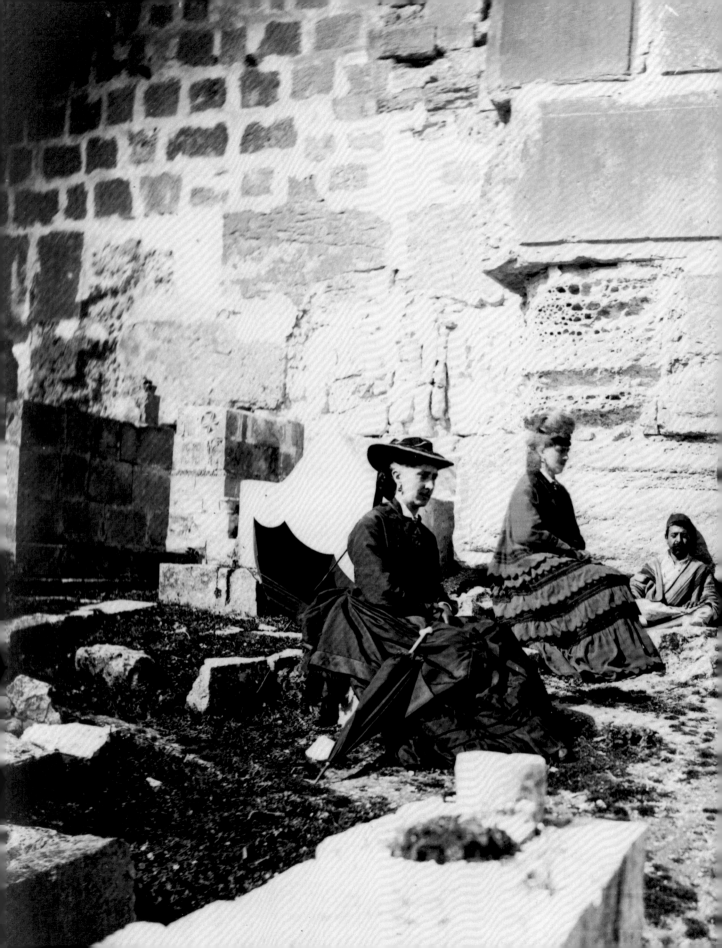

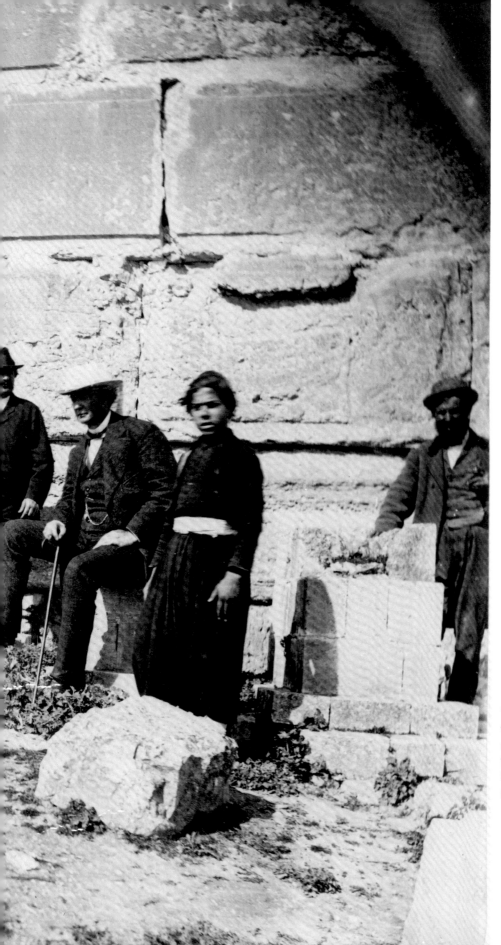

"Tourists" outside Jerusalem's walls. Are these photographs of Mark Twain's companions from *The Innocents Abroad*? Circa 1867. (*Library of Congress*)[iii]

The "tourists in a cemetery outside Jerusalem's walls," apparently outside the Golden Gate, circa 1867. (*Library of Congress*)[iv]

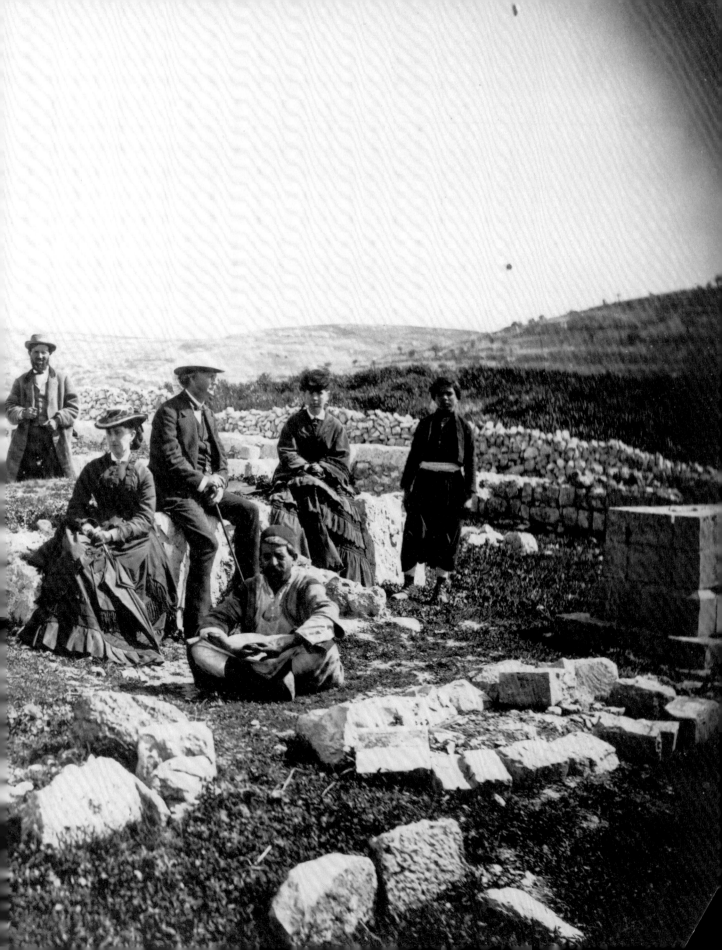

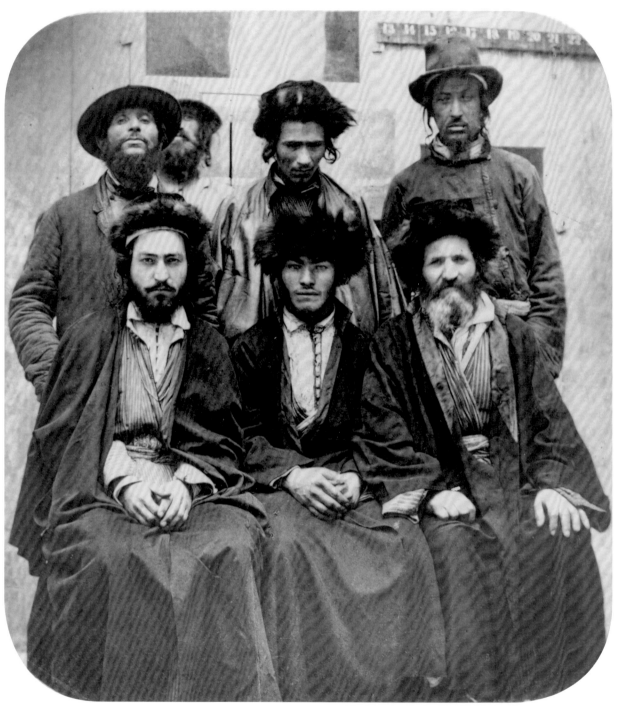

"Ashkenazim" (German Jews [sic]). Photograph was taken in the courtyard of the Mediterranean Hotel in the Muslim Quarter of Jerusalem, 1867. (*Library of Congress*)

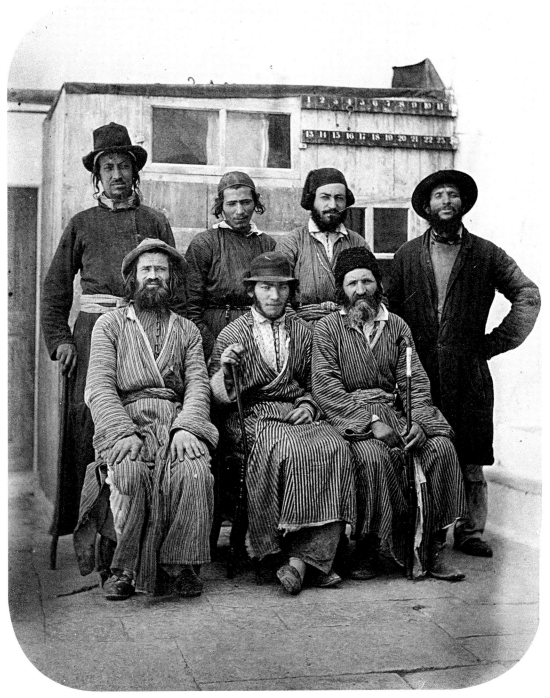

1867: Group of Polish Jews in the courtyard of the Mediterranean Hotel, Jerusalem.
Photographer: Henry Philips (Palestine Exploration Fund, *Twitter*)

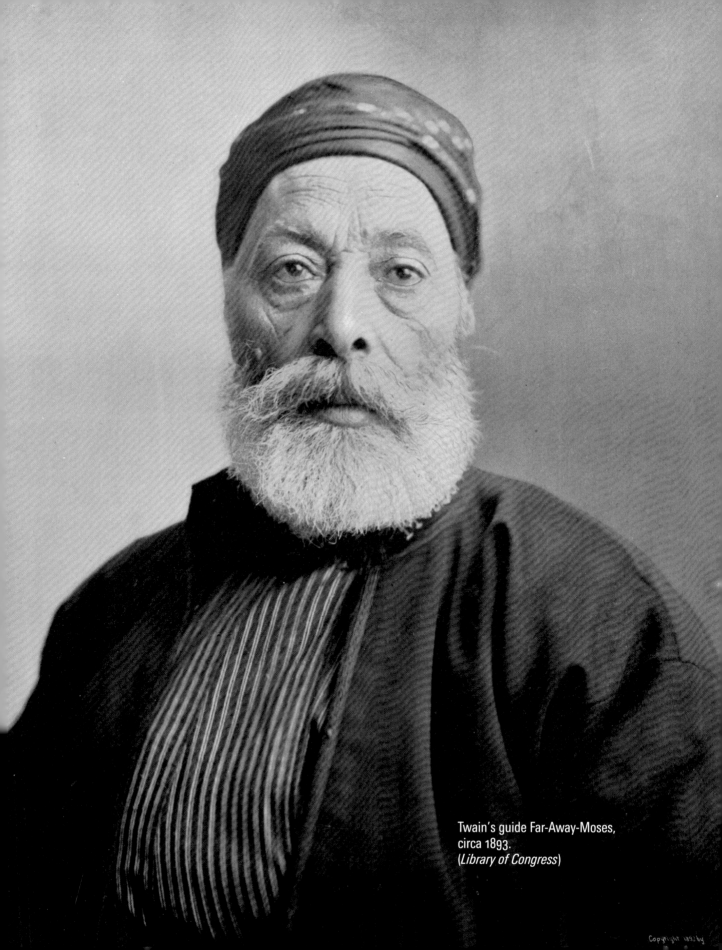

Twain's guide Far-Away-Moses, circa 1893.
(*Library of Congress*)

7 Why is an American Flag
on this "Vehicle"?

RESEARCHING AND GATHERING MATERIAL FOR THIS BOOK, I FOUND many photographs showing the American flag waving at celebrations or atop buildings or vehicles in the Holy Land. This picture is one of the most curious. The strange vehicle in the photo is called a palanquin, litter, or sedan. It is a mystery why an American flag waves from the top of this mule-borne contraption that was used in Lebanon

or Palestine around the 1870s. Furthermore, why did a French photographer take the picture?

The passenger appears to be a woman.

This photo is from a collection put online by the British Library's Endangered Archives Program. Perhaps it shows a litter used by an American diplomat or his family. The photo may have been taken in the 1870s in Beirut, Jerusalem or Jaffa.

The picture is part of the Fouad Debbas private collection in Beirut.[1] The collection of 3,000 photographs contains photographs from the Maison Bonfils studios of Paris and Beirut (1867–1910s). The British Library undertook to "clean, list, index, catalogue and digitize" a collection that was endangered.

Thank you to the staff of the British Library for their efforts and for opening the collection to the public.

Below is another photograph from the British Library's Endangered Archives Program and its digitized Debbas collection.

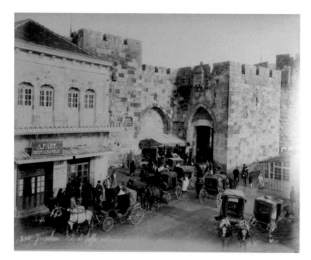

Photo by Bonfils of Jerusalem's Jaffa Gate, circa 1895, prior to breaking through the wall in 1898 to create a road and allow for the entry of carriages.

1. British Library Endangered Archives, http://eap.bl.uk/database/overview_item.a4d?catId =196125;r=41

8 Ulysses S. Grant's Very Long Voyage to the Holy Land

MOST AMERICANS KNOW ULYSSES S. GRANT AS THE COMMANDING general of the U.S. Army in the Civil War and as the 18th president of the United States between 1869 and 1877.

Less well known, however, is his infamous "General Order No. 11," expelling all Jews from Tennessee, Kentucky, and Mississippi, states under his military jurisdiction as general in the U.S. Army on December 17, 1862. According to historian Jonathan Sarna, Grant "issued the most notorious anti-Jewish official order in American history."[1]

Grant was concerned that black marketeers were illegally smuggling the South's raw cotton to the North's textile factories. Jews were identified among the "unprincipled traders,"[2] but Grant's edict was for the expulsion of *all* Jews.

The response to Grant's order was immediate and powerful. Telegrams and delegations of Jews flooded President Abraham Lincoln's White House. Members of Congress and some newspapers were outraged. Lincoln ordered that General Order No. 11 be "revoked immediately."[3]

1. Jonathan D. Sarna, *When General Grant Expelled the Jews* (Random House, 2012).
2. Letter from Gen. Ulysses S. Grant to C.P. Wolcott, Assistant Secretary of War, December 17, 1862. https://books.google.co.il/books , http://tinyurl.com/h272zxp
3. Kenneth D. Roseman, *Of Tribes and Tribulations* (Wipf and Stock Publishers, 2014).

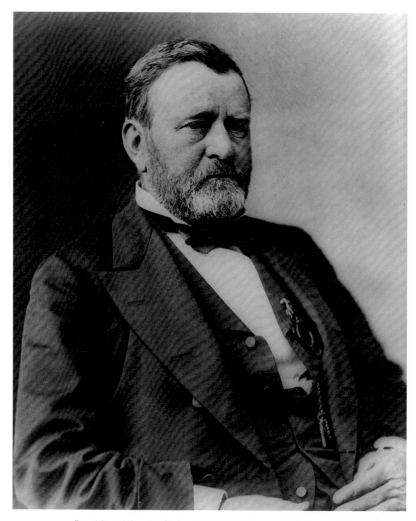

President Ulysses S. Grant, 1869. (*Library of Congress*)[i]

Grant's Remorse and Correcting the Wrong

Grant revoked the General Order on January 17, 1863. But it came back to haunt him during his race for the White House in 1868. When Democrats raised the issue of Grant's anti-Semitism, the former general pushed back, denounced the General Order and denied the charges of bias. He won the election.

In office, perhaps exhibiting contrition, President Grant "appointed more

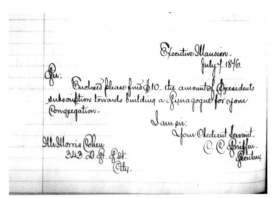

Synagogue receipt for President Grant's $10 donation, July 1876.
(*Jewish Historical Society of Greater Washington*)

Jews to public office than all previous presidents combined," according to historian Sarna.[4] Grant was forceful in denouncing anti-Jewish activities in Russia and Romania.

On June 9, 1876, Grant attended the dedication of Adas Israel Synagogue in Washington, D.C., the capital's first permanent Jewish house of worship, where all were retaining – "their hats, as was observed by the congregation."[5] A month later he sent a donation to the synagogue's building fund.[6]

To preserve the historic synagogue, the building was lifted and moved to a nearby location in 1969.[7]

Just months after taking office in 1869, President Grant received a visitor from the Holy Land, Rabbi Chaim Tzvi Schneerson, a descendent of the founder of the Chabad movement.[8] He appealed to Grant to take the Jews of Jerusalem under American protection. In accordance with the Europe-and-Ottoman capitulations agreements, foreigners in Palestine, particularly Christians, were, in effect, wards of the European consulates.

Schneerson also lodged a complaint against the missionizing practices

4. Jonathan D. Sarna, *General Grant's Uncivil War against Jews*, http://www.thejewishweek.com /news/national/gen_grants_uncivil_war_against_jews#fVW1S1r6OfwVODm6.99
5. *The Daily Critic*, June 10, 1876, Jewish Historical Society of Greater Washington, https://www .jhsgw.org/history/presidential-visit
6. *The Daily Critic*, June 10, 1876, Jewish Historical Society of Greater Washington, https://www .jhsgw.org/history/presidential-visit
7. (*The Daily Critic*, June 10, 1876), Jewish Historical Society of Greater Washington, https:// www.jhsgw.org/history/presidential-visit.
8. Dr. Yitzchok Levine, "The Jerusalem Rabbi Who Met President Ulysses S. Grant" (*Hamodia*, June 10, 2009). http://personal.stevens.edu/~llevine/schneersohn_hamodia.pdf

of the American Consul General, Victor Beauboucher, a Frenchman who had fought in the American Civil War and served as Consul between 1865 and 1870. The Consul and Protestant missionaries were pressuring a Jewish orphan, Sarah Steinberg, to convert.[9] Some claimed that the diplomat "kidnapped" her. Beauboucher was only one of several missionary-diplomats who would have rocky relations with the Jewish community and/or the Zionist enterprise.

Within months of leaving office, President Grant and his wife began a two-year tour of the world, meeting with kings, queens, popes, pashas, diplomats, and sultans and being received by adoring crowds everywhere. The corruption charges of his last term of office had not tarnished his reputation internationally as the man who saved the United States on the battlefield.

Grant's journey was chronicled by John Russell Young, a writer who recorded the former president's sightseeing and conversations and who was appointed years later as the Librarian of Congress.

Rabbi Chaim Tzvi Schneerson, 1869.
(*Hamodia*)

Although Grant's visit to the Holy Land was very short, his impressions of the land (expressed via Young) were remarkably similar to those of Grant's friend Mark Twain from ten years earlier:[10]

9. Ruth Kark, *American Counsels in the Holy Land, 1832–1914* (Wayne State University Press, 1994).
10. John Russell Young, *Around the world with General Grant: a narrative of the visit of General U.S. Grant, ex-president of the United States, to various countries in Europe, Asia, and Africa, in 1877, 1878, 1879. To which are added certain conversations with General Grant on questions connected*

"The utter absence of all civilization, of all trace of human existence," Young wrote, "is the fact that meets and oppresses you. . . . [Grant notes potential for the Plain of Sharon] under good government and tilled by such labor as could be found in America. . . . [But it] is an abandoned land, with barrenness written on every hillside. . . . The hills have been washed bare by centuries of neglect, and terraced slopes that were once rich with all the fruits of Palestine are sterile and abandoned. [On the road to Jerusalem] we went over hills that kept growing higher and over roads growing worse and worse. Some of us walked ahead and made short cuts to avoid the sinuous paths."

". . . Jerusalem has no form of beauty, except when seen from one of the hills, say from the Mount of Olives, and then its domes and minarets, its gray massive walls, its compact streets, blend into an imposing picture. As you slip over the rough cobble-stones, and fall into ruts, stumble on broken roads, and go through the noisome streets where life seems a fermentation, it is hard to feel that even in its holiest and sunniest days Jerusalem could have been 'the perfection of beauty, the joy of the whole earth.'"

Neither Grant nor Young detailed meetings with Jews in Jerusalem, but the illustration in Young's book provided a view of Jews at the Western Wall.

with American politics and history. (American News Company, 1879), https://catalog.hathit rust.org/Record/100598220

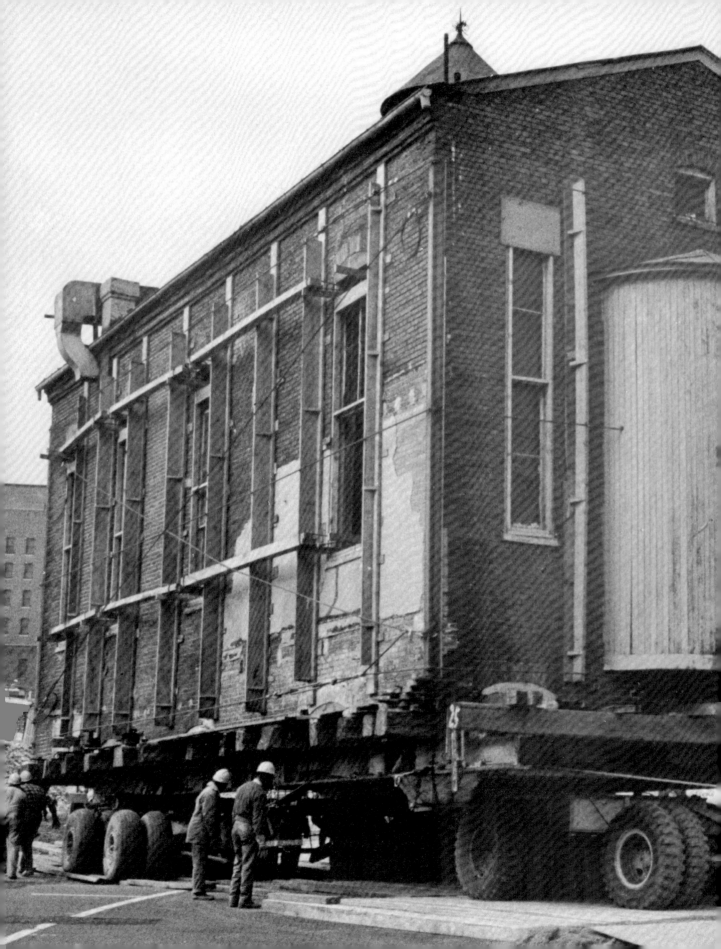

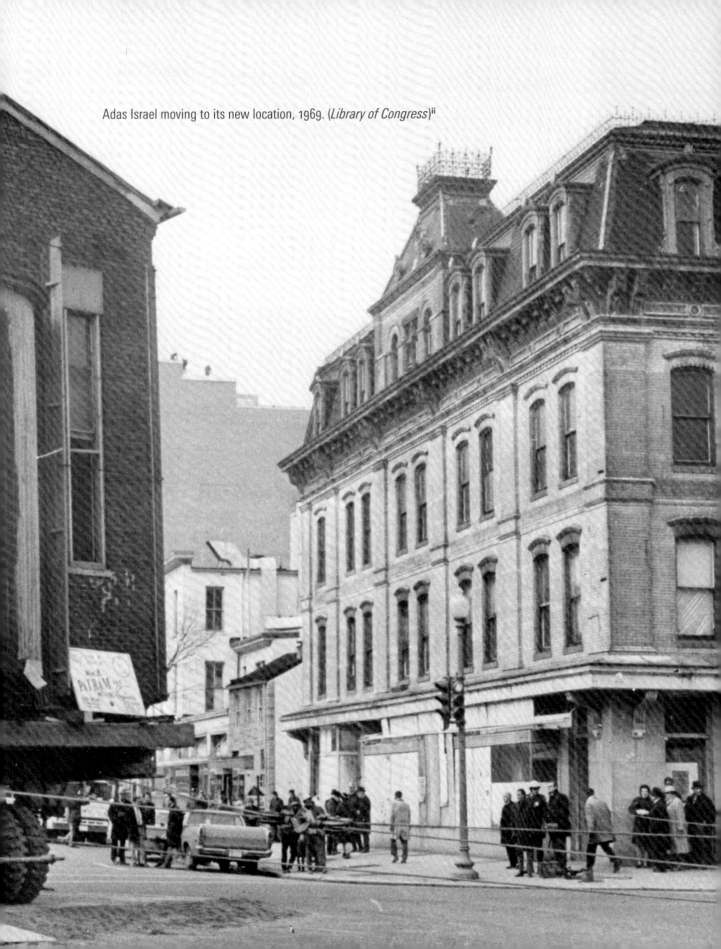

Adas Israel moving to its new location, 1969. (*Library of Congress*)[ii]

Illustration of the "Wailing Place of the Jews," 1877. (*From the Grant-Young book*)

Ulysses S. Grant (first row, center) in Egypt, circa 1877. (*Library of Congress*)

9 Can't Sail to the Holy Land — Visit Chautauqua, NY

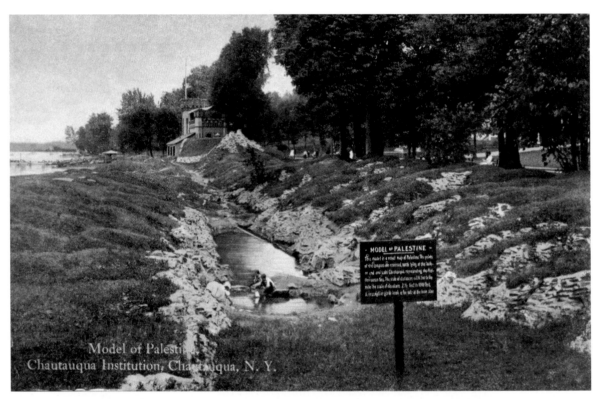

The "Sea of Galilee" at the model of Palestine in Chautauqua, N.Y., circa 1900. (*IsabellaAlden.com*)

AMERICAN INTEREST IN THE LAND OF THE BIBLE GREW TREMEN-dously in the last quarter of the 19th century. Following the publication of Mark Twain's blockbuster *Innocents Abroad* travelogue in 1869, President Grant's world tour in 1877, and the widespread circulation of photographs and lantern slides of the Holy Land,

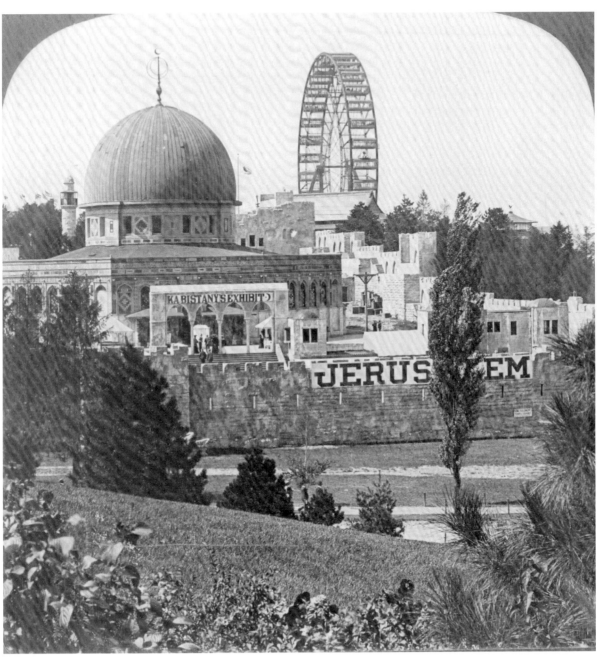

Jerusalem Old City model at the St. Louis World's Fair, with models of the Western Wall, Dome of the Rock, and Church of the Holy Sepulcher, in the shadow of the then-world's largest Ferris wheel, 1904. (*Library of Congress*)[i]

religious leaders and wise impresarios in the United States realized the potential of "bringing the Holy Land to America."

For those who couldn't go to Palestine, Jerusalem Diva Lydia Mary Olive Mamreoff Von Finkelstein Mountford (see chapter 12 – Madam Lydia, Diva of the Holy Land) performed her Bible performances across the United States, including at the model of Jerusalem's Old City displayed at the World's Fair in St. Louis, Missouri in 1904.

In 1874, the Chautauqua Institute was founded as a Christian learning center in western New York State, on the shores of Lake Chautauqua. Sunday school teachers would arrive at the institute by disembarking from their ferry boats to the shores of the "Holy Land" – Palestine Park, a to-scale miniature relief model of the land of the Bible from the Golan Mountains to the desert of the Negev. For the students at Chautauqua, Palestine Park was a visual aid for teaching Biblical history and geography.[1] Palestine Park has been renovated and expanded over the years to a 350-foot-long model.

According to the *Palestine Park Guide Book* from 1920:[2]

> *The model is a relief map of Palestine, showing the general contour of the country, and having the principal mountains, valleys, water-courses and cities plainly located. . . . It is to be noticed that on the model the points of the compass: north is toward the high mountains Lebanon and Hermon; and west is toward Chautauqua Lake, which represents the Mediterranean Sea.*

Visitors to Israel today can view a similar model of the Holy Land's sites with a visit to Mini Israel, located between Tel Aviv and Jerusalem. The elaborate miniature recreation features almost 400 replica models of Israel's historical, religious, and modern sites as well as Israel's major towns, ports, and industries.[3]

1. Isabella Alden, "A Tour of Chautauqua: Palestine Park." https://isabellaalden.com/tag/guide-book-to-palestine-park/
2. Isabella Alden, "A Tour of Chautauqua: Palestine Park." https://isabellaalden.com/tag/guide-book-to-palestine-park/
3. "The Park – Mini Israel, promotion." http://www.minisrael.co.il/en

The founder of Mini Israel, Eiran Gazit, is the CEO of "Gulliver's Gate," an innovative, interactive miniature display under construction in the center of Manhattan. Scheduled to be completed in 2017, Gulliver's Gate will present models of cities and famous sites from around the world, and the city of Jerusalem will be on display.

Palestine Park, looking at the "Sea of Galilee and the Jordan River," 2006. (*IsabellaAiden.com*)

Palestine Park, N.Y., 1908. (*IsabellaAiden.com*)

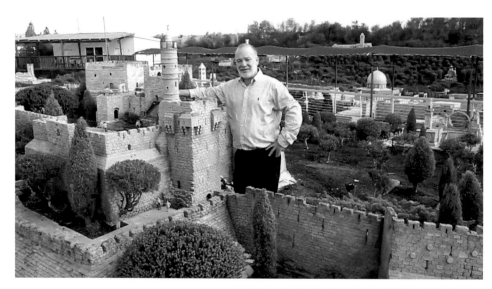

Eiran Gazit, Gulliver's Gate CEO, at Mini Israel.
(*Gulliver's Gate* promotional material)[ii]

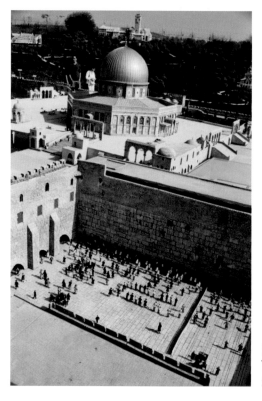

Mini Israel's version of the Western Wall,
Temple Mount and Dome of the Rock,
2002. (*Wiki Commons*)

10 The American Welcoming Committee for Yemenite Jewish Pilgrims to Jerusalem 130 Years Ago

ONLY ONE YEAR AFTER THE AMERICAN COLONY GROUP ARRIVED IN Jerusalem in 1881, they witnessed an amazing event that confirmed their belief in the imminent arrival of the Messiah. Hundreds of Yemenite Jews arrived in Jerusalem in 1882, after a long and difficult journey from Yemen.

Bertha Spafford Vester was the daughter of the founders of the Colony, Anne and Horatio Spafford. She described life in Jerusalem and her parents' relationship with the Yemenites in her fascinating book, *An American Family in the Holy City, 1881–1949.*[1] Many of the photographs of Yemenite Jews in this chapter were taken by the American Colony Photographic Department.

Vester wrote:

> *The Gadites entered our lives a few months after our arrival in Jerusalem . . . One afternoon in May 1882 several of the [American Colony] Group, including my parents, went for a walk, and were attracted by a strange-looking company of people camping in the fields. The weather was hot, and they had made shelters from the sun out of odds and ends of cloth, sacking, and bits of*

1. Bertha Spafford Vester, *Our Jerusalem: an American Family in the Holy City, 1881–1949* (Doubleday and Company, 1950), http://archive.org/stream/ourjerusalem000091mbp/our jersalem000091mbp_djvu.txt

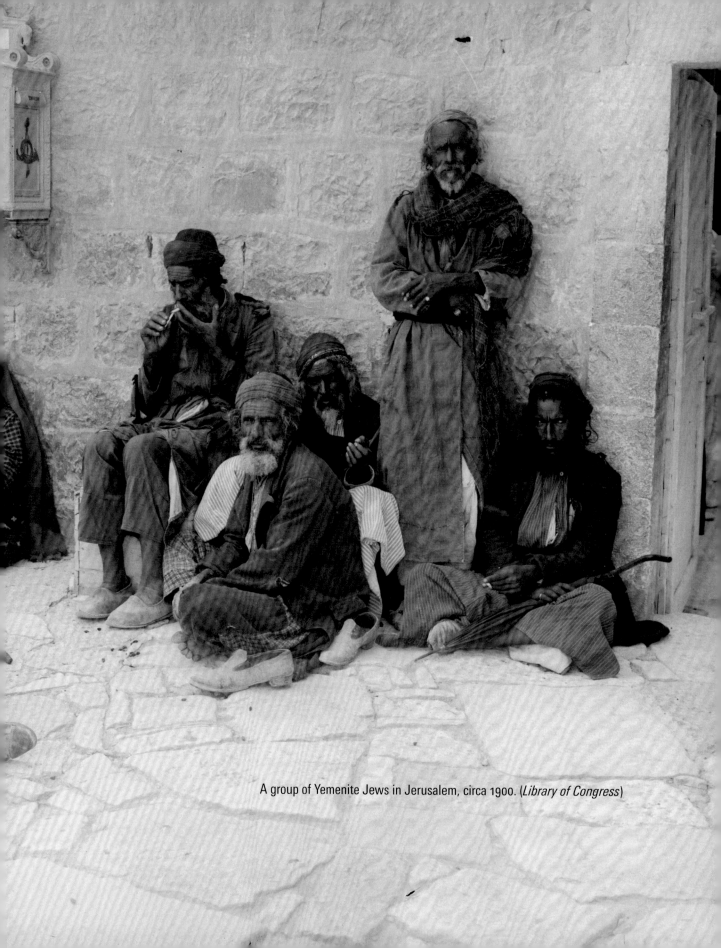

A group of Yemenite Jews in Jerusalem, circa 1900. (*Library of Congress*)

matting. Father made inquiries through the help of an interpreter and found that they were Yemenite Jews recently arrived from Arabia. . . . Suddenly [in Arabia], they said, without warning, a spirit seemed to fall on them and they began to speak about returning to the land of Israel. They were so convinced that this was the right and appointed time to return to Palestine that they sold their property and turned other convertible belongings into cash and started for the Promised Land. They said about five hundred had left Yena in Yemen. "Jews [in Jerusalem], they said, accused them of not being Jews but Arabs. One reason, they said, for their rejection by the Jerusalem Jews was because they feared that these poor immigrants would swell the number of recipients of halukkah, or prayer money [from foreign Jewish communities]. In 1882, when the Yemenites arrived, those who had benefited from the generosity of others were unwilling to pass it on.

The "Gadites"

"Father was interested in the Gadites at once," Vester continued. Their story about their unprovoked conviction that this was the time to return to Palestine coincided with what he felt sure was coming to pass the fulfillment of the prophecy of the return of the Jews to Palestine.
"I know there are other theories about how Jews got there, and about their origin, but Father believed that 'Blessed be he that enlargeth Gad,' and the Group did everything in their power to help these immigrants. We called them Gadites from that time."

According to Vester, *"They were in dreadful need when we found them."*

Some of them had died of exposure and starvation during their long and uncomfortable trip; now malaria, typhoid, and dysentery were doing their work. They had to be helped, and quickly. No time was lost in getting relief started. The [American Colony] Group rented rooms, and the Gadites were installed in cooler and more sanitary quarters. Medical help was immediately

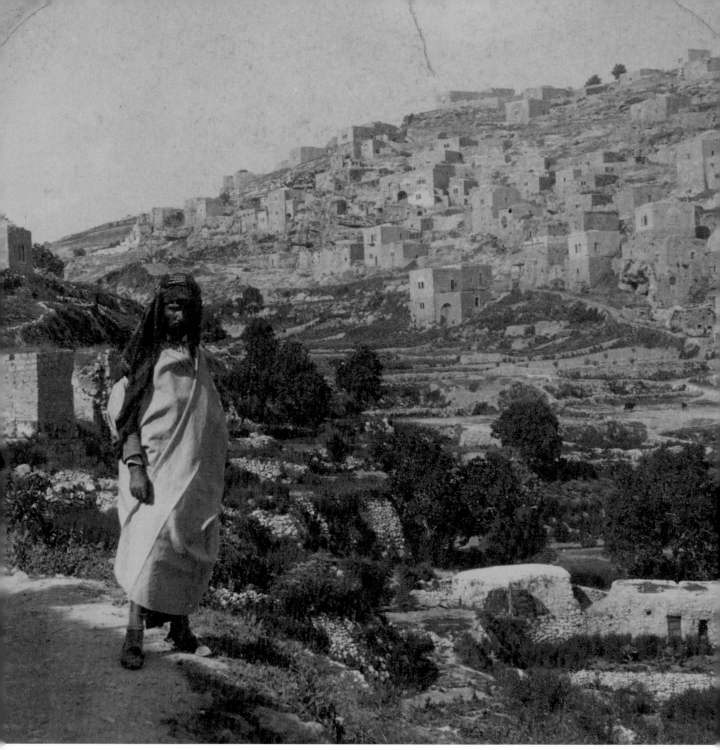

A Yemenite Jew standing above the village of Silwan. From his dress and long hair and side curls (*peyot*), he can be identified as a member of the Jewish Habbani tribe.[i] The Yemenites lived there in caves upon their arrival in 1882, circa 1901 (*Library of Congress*). The men of the Habbani tribe were known for their courage and strength and even served as mercenaries and bodyguards for local Muslim leaders, such as Emir Abdullah of Jordan. (See page 83.)

The "Gadite" (Yemenite) prayer in Spafford's Bible, 1882.
(*Library of Congress*)[ii]

brought. Mr. Steinharf's sister, an Orthodox Jewish woman, was engaged to
purchase kosher meat, which, with vegetables and rice or cracked burghal
(wheat) she made into a nutritious soup.

The Yemenite Jews – the "Gadites" – were very grateful, and they had an
unusual scribe from the community draft a prayer honoring the Spaffords.
The scribe had no use of his hands and wrote with his foot, Bertha Spafford
Vester wrote. Below is the scribe's Hebrew prayer, which was found in the
Spafford scrapbook, and the prayer's translation into English was written
in Horatio Spafford's Bible.

Prayer of Jewish Rabbi offered every Sabbath in Gadite synagogue, [June 27?]:
He who blessed our fathers Abraham, Isaac and Jacob, bless and guard and keep
Horatio Spafford and his household and all that are joined with him, because he
has shown us mercy to us and our children and little ones Therefore may the Lord

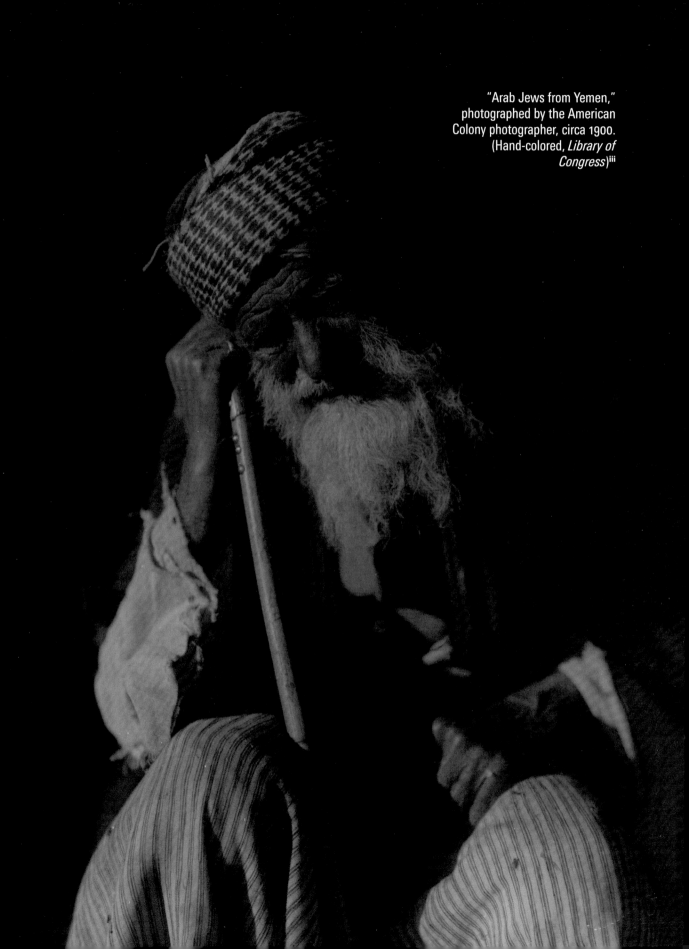

"Arab Jews from Yemen," photographed by the American Colony photographer, circa 1900. (Hand-colored, *Library of Congress*)[iii]

*make his days long . . . [?] and may the Lord's mercy shelter them. In his and in
our days may Judah be helped [?] and Israel rest peacefully and may the Redeemer
come to Zion, Amen.*

The Photograph Below Also Serves as an 1890 Address Book

In recent years, the British Library has been conducting its Endangered
Archives Programme[2] to identify and preserve historic photograph collec-
tions around the world. One such collection was the Fouad Debbas archive
in Beirut, Lebanon, with 3,000 pictures taken by the photographic pioneers
in Maison Bonfils (1867–1910). A digitized photograph from a Bonfils album[3]

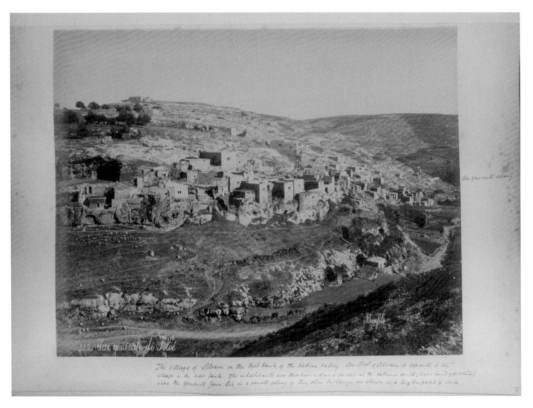

2. British Library, Endangered Archives Programme, http://eap.bl.uk/index.a4d
3. British Library, Endangered Archives Programme, Silwan, http://eap.bl.uk, http://tinyurl
 .com/hvjtcfw

Original prayer (top) written by foot by the scribe in Jerusalem, 1882, and an English translation. (*Library of Congress*)[iv]

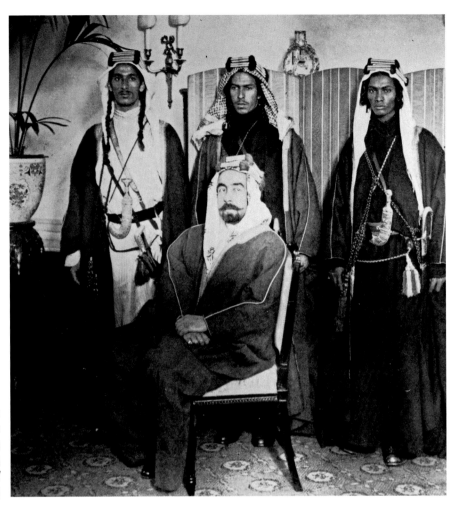

King Abdullah I of Jordan with his Habbani Jewish bodyguards, the brothers Sayeed, Salaah, and Saadia Sofer, c. 1922. (*World History Archive/Alamy*)

shows the village of Silwan/Siloam/Shiloah outside of Jerusalem's Old City, an ancient site dating back to the Jewish Temples. In the caves of Silwan the Yemenite Jews found shelter and were provided for by the American Colony. The Bonfils photo (circa 1895) included an enlightening caption, written in English, as well as a note on the side of the photo, "The Yemenite Colony."

The caption reads:

> *The village of Siloam on the east bank of the Kidron Valley. The Pool of Siloam is opposite to the village on the west bank. The inhabitants are Mohammedans except at the extreme south (right hand of picture) where the Yemenite Jews live in a small colony of tiny stone buildings as shown in a long low patch of white.*

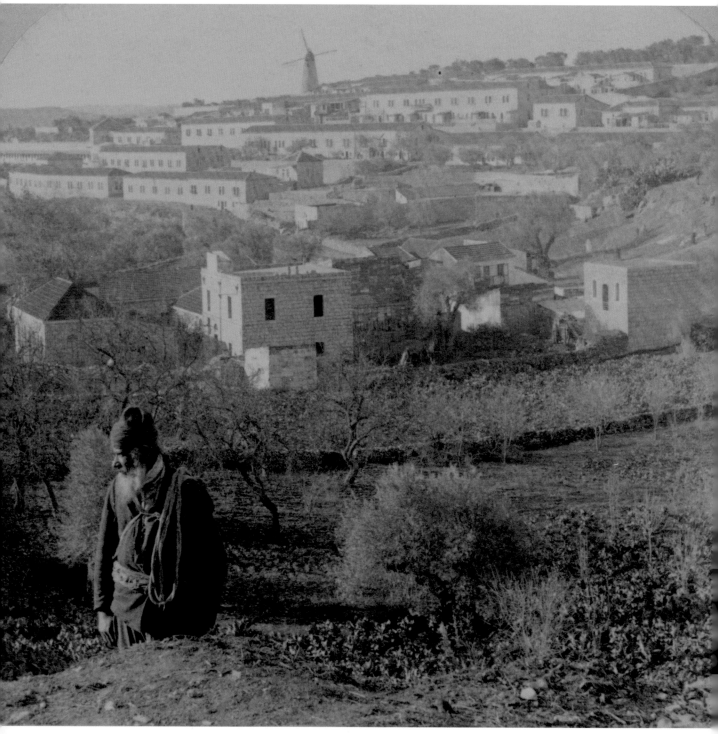

Yemenite Jew near Yemin Moshe, Mishkenot Sha'ananim project in Jerusalem, circa 1899. (*Library of Congress*)ᵛ

11 Bringing the Holy Land to America, Together with Mark Twain's Guide

A s American interest in the Holy Land grew in the second half of the 19th century, entrepreneurs and Bible scholars attempted to "re-create" the wondrously exotic land of the Bible in the United States. A huge scale model of the Holy Land from Mount Hebron to Be'er Sheba was constructed as "Palestine Park" in Lake Chautauqua, N.Y., in 1874. A Middle East Pavilion was built for the 1893 World Exposition in Chicago, and the Old City of Jerusalem was re-created at the 1904 Louisiana Purchase World's Fair in St. Louis.

Portrait of a "Constantinople Jewish Guide," circa 1880. (*Ottoman Imperial Archives, author's collection*)

America Clamored for "Far-Away-Moses," Mark Twain's Guide in the Holy Land

Could the "Jewish Guide" pictured here be the man who guided Twain in 1867? This rare picture found in the Imperial Ottoman Archives is captioned "Type of Constantinople Jewish Guide." It certainly appears to be a younger version of Far-Away-Moses whose portrait for the 1893 Chicago Fair appears previously.

The Dome of the Rock and Old City photographed from the Ferris wheel at the St. Louis Exposition, 1904.
(*Library of Congress*)[i]

Mark Twain's account of his 1867 visit to the Middle East in *Innocents Abroad* launched his career as America's foremost storyteller. In his book, he dubbed his quirky Turkish dragoman (guide) "Far-Away Moses" and elevated him to a legendary figure. (See Chapter 6 – Mark Twain in the Holy Land.)

In 1870, Twain reported to his publisher, "I learn from Constantinople that the celebrated guide, 'Far-Away-Moses' goes to the American Consulate and borrows my book to read the chapter about himself to English and Americans, and he sends me a beseeching request that I will forward a copy of *that chapter* to him – he don't want [sic] the whole book, but only just that to use as an advertisement. . . ."[1]

Years later, "Far-Away-Moses" was one of the attractions at the 1893 Chicago World's Fair. However, Far-Away-Moses alone was not a major draw. The advertising campaign for the 1893 Chicago pavilion was not very successful: "*Life in the Holy Lands! Scenes from Biblical Days!!! The Historic East as It Is and Was!!! A Moral Show!!!*"

Crowds were not attracted to a moral show, wrote researcher Barbara Kirshenblatt-Gimblett in *Jews and the Holy Land at World's Fairs,* until the Turkish proprietor changed the campaign to "*Life in the Harem!! Dreamy Scenes in the Orient!!! Eastern Dances!!! The Sultan's Diversions.*"[2]

Kirshenblatt-Gimblett added, "The proprietor in the doorway and belly dancer on the placard [outside] were in all likelihood Jewish."[3] According to other sources, one of the proprietors was none other than Far-Away-Moses, apparently also known as Harry R. Mandil, an American citizen.[4]

Another partner was R.J. Levi (pictured), identified as a "Jewish chef and caterer from Constantinople [who] was manager and chief proprietor of the Turkish Village and Theatre."[5]

1. Mark Twain's Letters, Volume 4: 1870–1871, page 184.
2. Barbara Kirshenblatt-Gimblett, *Destination Culture: Tourism, Museums, and Heritage,* (University of California Press, 1998).
3. Zeynep Çelik, *Displaying the Orient: Architecture of Islam at Nineteenth-Century World's Fairs,* (Berkeley: University of California Press, 1992), http://ark.cdlib.org/ark:/13030/ft8x0nb62g/
4. Jeffrey Shandler, and Beth S. Wenger. *Encounters with the "Holy Land"*: Place, Past and Future in American Jewish Culture, (University of Pennsylvania, 1998).
5. Barbara Kirshenblatt-Gimblett, *Destination Culture: Tourism, Museums, and Heritage* (University of California Press, 1998).

R. J. Levy, 1893. (*Ottoman Imperial Library, Author's collection*)

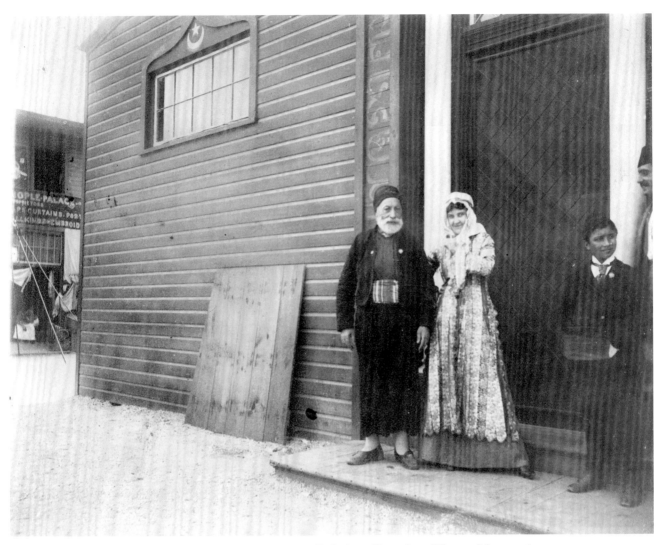

Far-Away-Moses on the "set" of the Turkish pavilion, 1893. (*Library of Congress*)

12 Madam Lydia, Diva of the Holy Land

T ODAY, MADAM LYDIA MARY OLIVE MAMREOFF VON FINKELSTEIN Mountford (1855–1917) is unknown. But in the early 1900s, she was famous around the world and conveyed a love of Zion to her many audiences. Performances, books, and lectures such as hers and Mark Twain's stirred many American Christians who dreamed about the Holy Land.

Lydia Von Finkelstein[1] was born in Jerusalem in 1855 to a Russian family, apparently Jewish. She spoke Russian, Arabic, Hebrew, German, English, and French. The family converted to Christianity, and, later in life, she became a Mormon. As a popular actress, missionary, and news correspondent, Lydia traveled to the United States, Great Britain, India, Australia, and New Zealand, presenting Bible-based plays. She filed news reports on the German Emperor's visit to Jerusalem in 1898 and appears in the bottom left of the picture below with a reporter's pad in hand at the Jewish reception for the Emperor.

Several clippings about her Biblical performances in the 1880s in New Zealand appear in newspaper archives. One article in the *Aroha News*,[2] however, was written by Von Finkelstein herself and was entitled "Palestine Fifty Years Ago and Palestine Today." Her observations about life in the Holy Land for Christians and Jews are fascinating, and excerpts are presented below:

1. Nelson B. Wadsworth, "Set in Stone, Fixed in Glass," Signature Books Library, http://signaturebookslibrary.org/set-in-stone-fixed-in-glass-7-charles-ellis-johnson/

2. *Te Aroha News*, October 28, 1888, http://paperspast.natlib.govt.nz/cgi-bin/paperspast, http://tinyurl.com/zqzxuq5

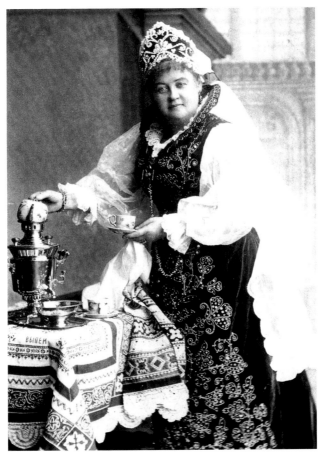

Lydia Von Finkelstein Mountford, circa 1897. (*Set in Stone, Fixed in Glass*)[i]

About fifty years ago, with the exception of some Polish Jewish families, and a few Latin monks, there were no European residents in Jerusalem. At that period the Jews did not contribute either to the civilisation of the inhabitants or the improvement of the city, but adapted themselves to the manners of the people and the exigencies of the place. The monks confined themselves to their daily avocations in the convents, and to the entertainment of wealthy pilgrims and travellers, whose visits, like those of angels, were few and far between.

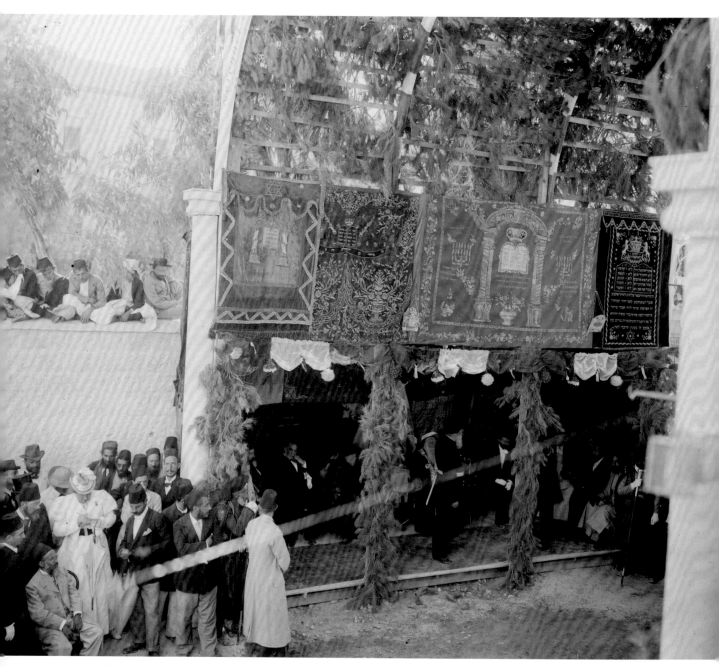

Receiving the German Emperor. Von Finkelstein, the reporter, is at the bottom left in the white dress, 1898.
(*Library of Congress Prints and Photographs*)[ii]

The Jews, as well as the native Christians, throughout Syria and Palestine, were daily and hourly subjected to oppression, extortions, exaction, robbery and insults from their Moslem neighbours. It was no unusual occurrence for the Moslem to enter their houses, ransack closets and boxes, and appropriate any article of wearing apparel, furniture, or food that took the marauder's fancy. The local Government authorities would occasionally, when in need of funds, levy blackmail to the amount of hundreds of pounds on the Jews and native Christians, threatening them with massacre and plunder in default of payment. Consequently, Jews and native Christians dared to make any display of wealth only at the risk of losing life or property, and often both. . . .

The Arrival of Missionaries

With the advent of the American and English missionaries came the dawn of a brighter day for the Holy City, and indeed for the whole country. On account of Moslem fanaticism and prejudice, these messengers of the Gospel, and consequently pioneers of civilisation, were obliged for a certain period of time to adopt the Oriental dress for safety. The Oriental furniture, utensils, and cuisine, though in many respects better adapted to the climate and surroundings, were so entirely different to those of Europe and America, that those early settlers, wealthy or otherwise, may truly be said to have endured hardships and privations great and innumerable. Occidental furniture, utensils, crockery or glass, were not to be had for love or money; and only those fortunate families or individuals possessed them who had had sufficient foresight to bring such articles from their homes in Europe. Further, there was not a window in any house in Jerusalem that had a pane of glass in it; wooden lattices, shutters, and iron bars being the order of the day.[3]

3. New York Public Library, "Views within the City: Pool of Hezekiah, 1865," http://digitalcoll ections.nypl.org/items/510d47d9-646d-a3d9-e040-e00a18064a99#/?zoom=true

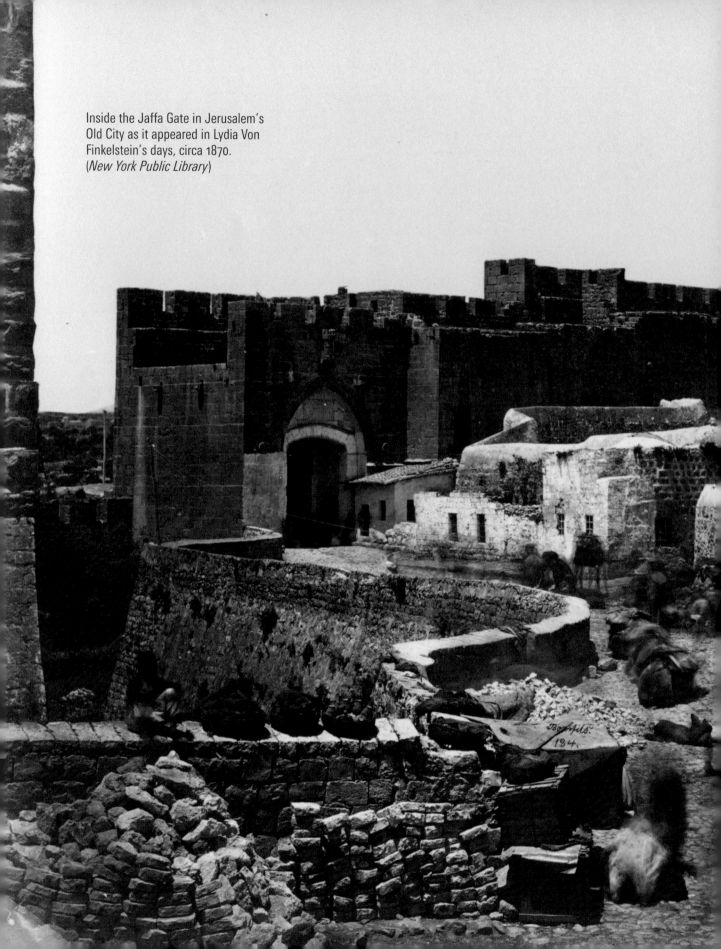

Inside the Jaffa Gate in Jerusalem's Old City as it appeared in Lydia Von Finkelstein's days, circa 1870. (*New York Public Library*)

Hezekiah's Pool in Jerusalem's Old City. All those windows and not a pane of glass, 1865.
(New York Public Library)

All Mail and Goods Came via "Beirout"

About the year 1845, a European merchant first imported —at great inconvenience, risk, and cost, having to travel to Beirout and Alexandria to make the purchase – Occidental furniture, crockery, and window glass. There were no facilities for travel, and no steamers touched at the port of Jaffa. Once, and later twice a year, the Jewish, Latin, and other communities sent messengers to Beirout from Jerusalem, a journey of about 150 miles overland, to fetch the mails and other matter that might have been brought by the steamers from

Alexandria and Constantinople, which at stated periods touched for a few
hours at Beirout. About the year 1845 steamers began to stop occasionally
at the port of Jaffa. . . .

The Diva's American Connection

Madame Lydia moved to the United States in 1877. When she returned to
the Holy Land nine years later she applied at the American consulate for
citizenship[4] but was denied, despite the fact that her mother and brother
had once worked there. Nevertheless, she appeared prominently in the
United States, including performances at the re-creation of Jerusalem at
the World's Fair in St. Louis, Missouri, in 1904. At the opening of the exhibit,
Madame Lydia ("elocutionist and fantasist of Biblical life") declared, "You
cannot go to Jerusalem, so Jerusalem comes to you. To American energy all
things are possible."[5]

Lydia Von Finkelstein was also a welcomed performer in the state of Utah,
where she presented her Bible-based plays. She was particularly popular
among Mormons. The president of the Church of Latter Day Saints, Wilford
Woodruff, wrote, "I took my family to the theater to listen to another lecture
of Mrs. Lydia Mumford [sic] on Jerusalem. Her lectures are the most inter-
esting of any I attended on the Holy Land." According to several accounts,
the actress-preacher was baptized, converted by the Mormon Church,[6]
and became the polygamous Woodruff's second wife. According to several
accounts, she was married at the time to a British civil servant in India,
Charles Mountford.[7]

4. Tom Segev, "When Empires Crumbled and Jerusalem's Skyline Changed" (*Haaretz*, 9 Nov
 2012), http://www.haaretz.com/israel-news/when-empires-crumbled-and-jerusalem-s-s
 kyline-changed-1.476412
5. Sara B. Dykins Callahan, Graduate Thesis, "Where Christ dies daily: Performances of faith
 at Orlando's Holy Land Experience, (University of South Florida Scholar Commons, 2010),
 http://scholarcommons.usf.edu/cgi/viewcontent.cgi?article=2585&context=etd
6. Nelson B. Wadsworth, "Set in Stone, Fixed in Glass," Signature Books Library, http://signa
 turebookslibrary.org/set-in-stone-fixed-in-glass-7-charles-ellis-johnson/
7. Carmon B. Hardy, *Solemn Covenant: The Mormon Polygamous Passage* (University of Illinois
 Press, 1992), https://books.google.co.il/books

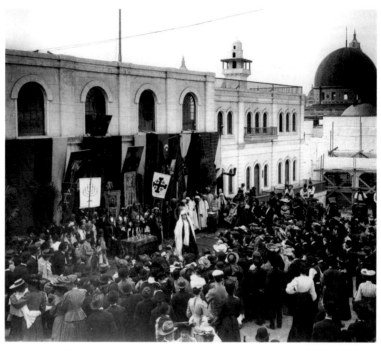

Von Finkelstein's performance – not in Jerusalem – but at a replica of Jerusalem, at the St. Louis World's Fair. Note the Christian and Jewish banners on the stage, 1904. (*Set in Stone, Fixed in Glass*)[iii]

In one of her last letters, Von Finkelstein expressed satisfaction that the British forces had attacked Ottoman forces in Gaza; she had prayed they would occupy all of Palestine. "For a long time," she wrote, "I have not cared to ever go again to Jerusalem, but now that the English will not, I know, try to make a mongrel, godless city of it, as all others would have done, I would like to see it again."[8] But she died a short time later in March 1917 in Lakeland, Florida, at the age of 69.[9]

8. Find a Grave, http://www.findagrave.com/cgi-bin/fg.cgi?page=gr&GRid=91465038
9. Nelson B. Wadsworth, "Set in Stone, Fixed in Glass," Signature Books Library, http://signaturebookslibrary.org/set-in-stone-fixed-in-glass-7-charles-ellis-johnson/

13 Theodore Roosevelt and the Holy Land — "Bully for You!"

Theodore Roosevelt, the 26th President of the United States (1901–1909), played a vital role in turning the United States into a global power. As president, he showed concern for the oppressed Jews of North Africa and Czarist Russia. After his presidency, he expressed strong support for the emergence of a Jewish state in Palestine.

Roosevelt's first contact with the Jews of Palestine was as a teen when his family toured the Middle East in 1872–1873. A perspicacious young man, Roosevelt wrote a diary of his trip which included his observations of the Jews' prayer at the Western Wall: "In the afternoon we went to the Wailing Place of the Jews. Many of the women were in earnest, but most of the men were evidently shamming."[1]

As a young politician, Roosevelt served as police commissioner of New York City, a role that brought him into contact with the Jewish community of New York. One young immigrant, Otto Raphael, was encouraged by Roosevelt to become a New York policeman, and the two men maintained a very close friendship until Roosevelt died. Raphael visited the president regularly at the White House.

The relationship is described in the book, *Officer Otto Raphael: A Jewish Friend of Theodore Roosevelt,* by Nancy Schoenburg.[2] On June 5, 1903, Raphael

1. Theodore Roosevelt Diaries, page 89, Harvard University Library, https://iiif.lib.harvard.edu/manifests/view/drs:23392680$95i
2. Nancy Schoenburg, http://americanjewisharchives.org/publications/journal/PDF/1987_39_01_00_schoenburg pdf

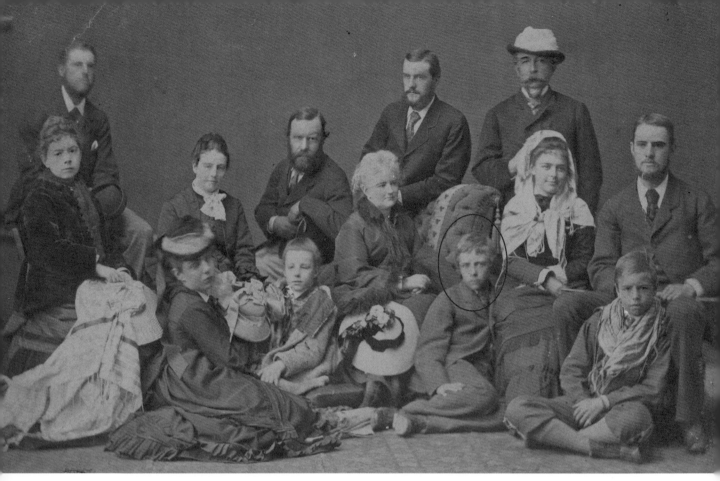

Young Theodore (in the circle) and the Roosevelt family "On the Nile, winter 1872–1873."
(*Theodore Roosevelt Collection, Harvard College Library*)[i]

wrote to Roosevelt, "Dear Friend, I feel I owe it to my people to join with them in asking you to do what you can in regard to the trouble and cowardly murders of the innocent Jews in Kishineff [sic]." The policeman continued, "I feel proud and happy to be able as a Jew to ask the President of the United States as my personal friend to intercede for my people. . . ."[3] In response, Roosevelt issued a strong letter of rebuke to the Russian Czar.

As president and former secretary of the navy, Roosevelt was quick to resort to "gunboat diplomacy," especially in the Middle East. In his book, *Power, Faith, and Fantasy,* Ambassador Michael B. Oren notes that as part of his negotiations over the rule of Morocco, the president "secured his

3. Nancy Schoenburg, http://americanjewisharchives.org/publications/journal/PDF/1987_39_01_00_schoenburg.pdf

Wailing Place of the Jews. Many of the women were in earnest, but most of the men were evidently shamming. The Stewards rode to the tombs of the judges and then to the tombs of the kings. Both were under ground, plain and without any ornamentation.

March 1st 1873. Saturday. Jerusalem.
We went in the morning to a convent and bought photographs. Had a ride.

March 2d 1873. Sunday. Jerusalem.
We went to a Protestant church in the morning. I enjoyed the sermon a good deal.

March 3d 1873. Monday. Jericho.
In the morning we started off on horseback for the Dead Sea. The way was bad, and so we did not go very fast. We saw a good many birds and I killed some. We stopped for lunch, under "the shadow of a great rock in a thirsty land." We reached here before five o'clock and I went out shooting immediately. We

Women of the Wall. From 15-year-old Teddy Roosevelt's diary, 1872.
(*Harvard University Library*)

country's customary concerns in the area, protecting North African Jews from oppression and American merchants from unfair restrictions and fees."[4]

Oren's opus on America and the Middle East also cites correspondence by Roosevelt in 1918 in which he wrote, "It seems to me that it is entirely proper to start a Zionist State around Jerusalem." In another letter, the former president stated, "[T]here can be no peace worth having" until Armenians and Arabs are granted independence "and the Jews given control of Palestine."[5]

4. Michael Oren, *Power, Faith, and Fantasy: America in the Middle East: 1776 to the Present* (W.W. Norton and Company, 2007), page 316.
5. Michael Oren, *Power, Faith, and Fantasy: America in the Middle East: 1776 to the Present* (W.W. Norton and Company, 2007), page 359.

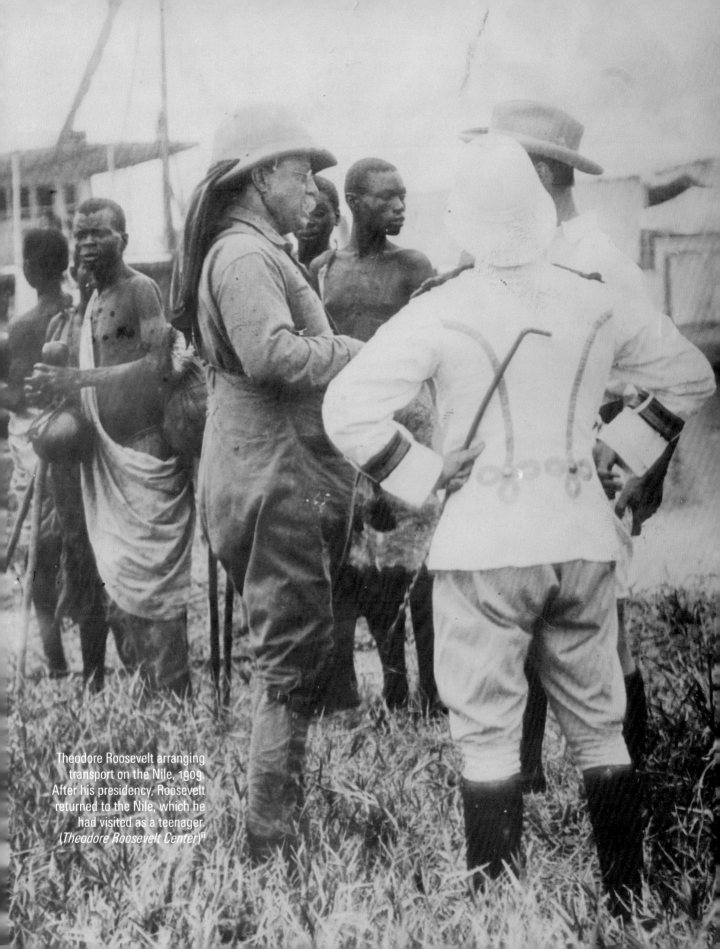

Theodore Roosevelt arranging transport on the Nile, 1909. After his presidency, Roosevelt returned to the Nile, which he had visited as a teenager. (*Theodore Roosevelt Center*)[ii]

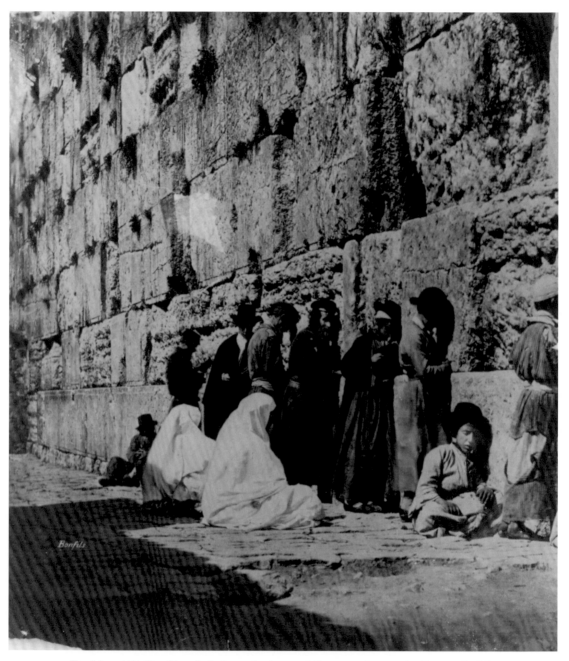

The "Jews' Wailing Place" photographed around the same time as the Roosevelt visit.
Typically, such early photographs at the Wall were posed, 1880s.
(Félix Bonfils, Library of Congress)[iii]

14 Celebrating July 4th in the Holy Land 100 Years Ago

THE CHICAGO FOUNDERS OF THE AMERICAN COLONY IN JERUSALEM in 1881 were proud of their American roots. The group of utopian, millennialist Christians was later joined by Swedish-American and Swedish believers.

The American Colony set up clinics, orphanages, cottage industries, and soup kitchens for the poor of Jerusalem, earning favor with the Turkish rulers of Palestine. Their concern for all citizens of Jerusalem was evident in the shelter and assistance they provided to destitute Yemenite Jews who arrived in Jerusalem in 1882.

When World War I broke out, the American Colony's photographers were able to work on both sides of the conflict.

The British army, under General Edmund Allenby, captured Jerusalem in December 1917. Seven months later, in 1918, Allenby was the guest of honor at the American Colony's July 4th celebrations.

Today, the American ambassador to Israel (who, as of this writing, resides in Herzylia) and the American Consul General in Jerusalem conduct separate July 4th receptions for thousands of Israelis and leaders of Jerusalem's diverse population, respectively. The reception at the ambassador's residence is usually attended by Israel's president and prime minister, opening with a U.S. Marine Color Guard, and concluding with fireworks over the Mediterranean.

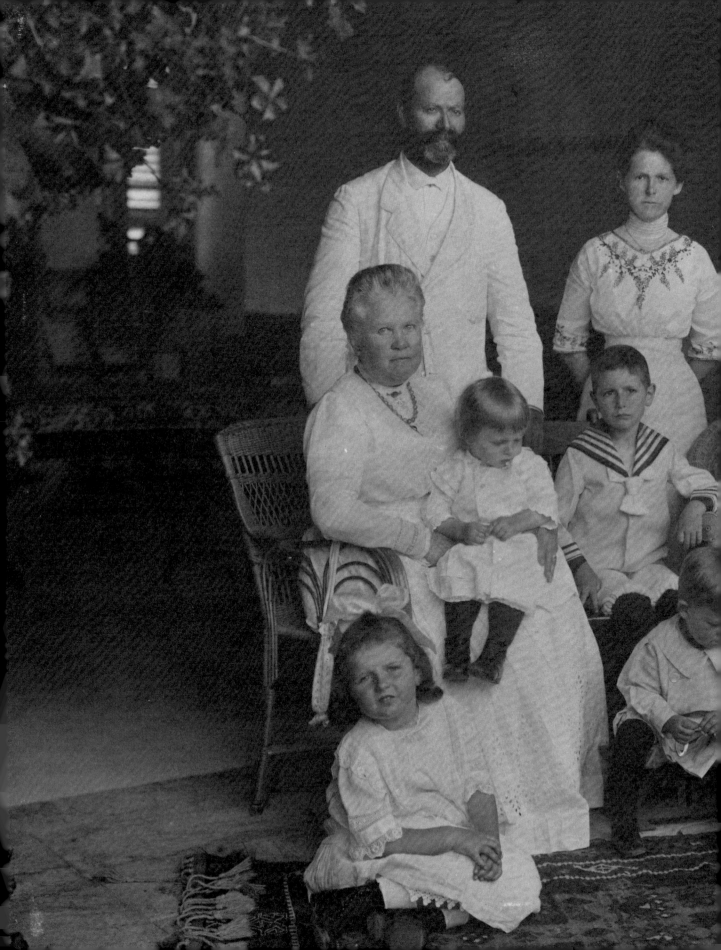

Founders of the American Colony. The founders' adopted son Jacob, born a Jew, is standing at the top left, circa 1905. (*Library of Congress*)[i]

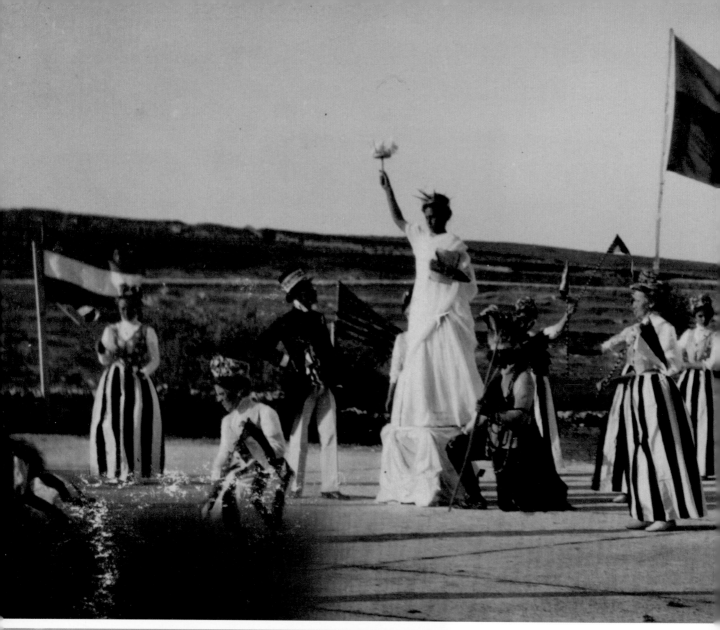

4th of July pageant, with man and woman dressed as Uncle Sam and the Statue of Liberty, Hand-colored picture, circa 1905. (*Library of Congress*)[ii]

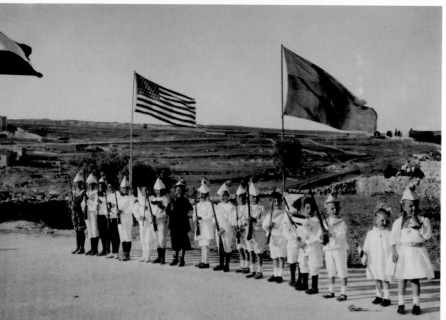

American Colony's 4th of July commemoration in Jerusalem with flags and toy guns. Note the Swedish flag; some of the American Colony members were originally Swedish. Hand-colored picture, circa 1905. (*Library of Congress*)[iii]

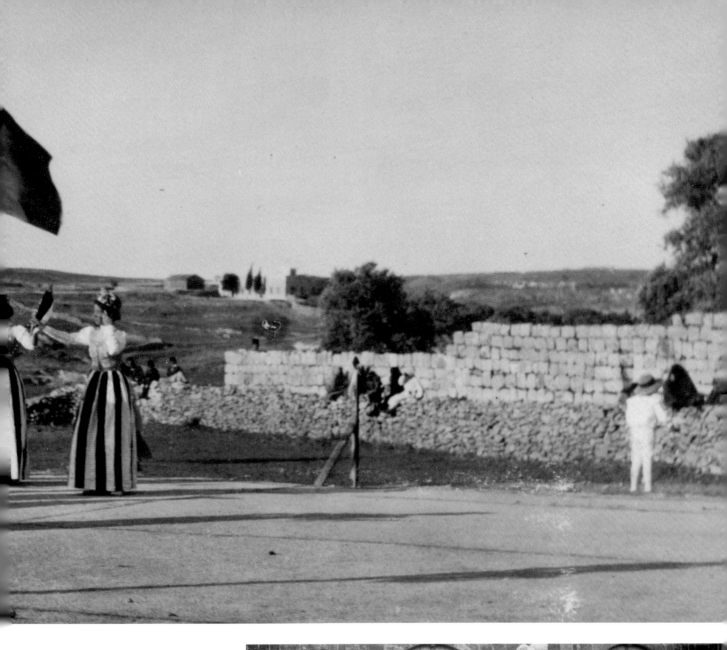

Allenby at the American Colony's pageant, July 4, 1918. (*Library of Congress*)[iv]

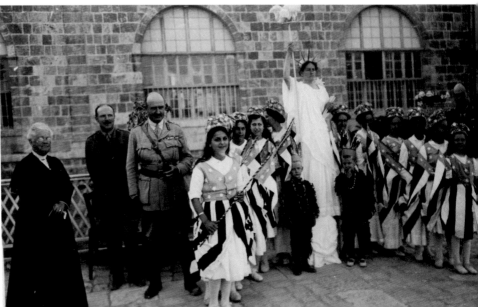

15 Waters of the Jordan Flowed to Kentucky in 1906 and Muddied an Anti-Semitic U.S. Diplomat's Reputation

THE INTERNATIONAL RIVER JORDAN WATER COMPANY WAS LAUNCHED by Col. Clifford E. Nadaud of Covington, Kentucky, in 1906. He secured "the sole right of shipping the water of the Jordan River from the banks of the stream in Palestine to all parts of the world for baptismal and other purposes," according to a Kentucky newspaper, *The Bee*, published in Earlington, KY.[1]

Jordan water is being conveyed to America in large quantities. The project was formed and carried out by Colon. G. E. Nadaud of Kentucky, who had a great many obstacles to overcome. He had first to get a concession from the Sultan and then to convey the water seventy miles to the seacoast across the mountains of Judea. Casks were not to be had and had to be made of wood brought from Asia Minor. The persons in the photograph are in the centre, Colonel Nadaud, at his left, the long white bearded figure is Father Maximos of St Johns Convent near the Jordan, representing the Patriarch of Jerusalem; to the colonel's right stand Ali Riza, Governor of Jericho and the Jordan, and to his left, Mr. Golat, interpreter of the American Consulate of Jerusalem. The

1. "Water from the Jordan." (*The Bee*, Earlington, Kentucky, 20 September, 1906). *http://kdl.ky vl.org/catalog/xt795x25bz4z_6/viewer*

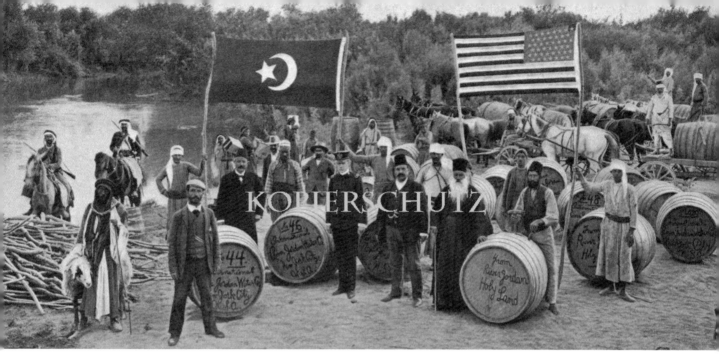

Original caption from the *Illustrated London News*: A shipment of Jordan water. Officials of an American Company at work on the traditional scene of our Lord's baptism, 1906. (Photograph from The Ottoman Imperial Archives, no longer under copy protection, courtesy of the author's private collection)

mounted men are Turkish cavalry soldiers sent to protect the party. The water is sold for baptismal purposes and at Negro revival services.

Nadaud "had a great many obstacles to overcome," reads the caption from the *Illustrated London News*, including getting "the concession from the Sultan and then to convey the water seventy miles to the seaport across the mountains to Jaffa."

"The water will be shipped in casks bearing the seals of the Turkish Government and the American Consul," according to *The Bee*. "The water will be bottled in the United States in bonded warehouses."

Nadaud received assistance from the American consul in Jerusalem, Selah Merrill, according to author Lester Vogel in *To See a Promised Land: Americans in the Holy Land in the Nineteenth Century*.[2] Merrill drew criticism from the U.S. Government for providing the official consular stamp.

Nadaud had to secure wagons and Jerusalem staff for his endeavor, Vogel wrote, and "he commissioned the construction of 53 giant casks and set up a

2. Lester I. Vogel, "To See a Promised Land: Americans in the Holy Land in the Nineteenth Century" (Penn State Press, 2010).

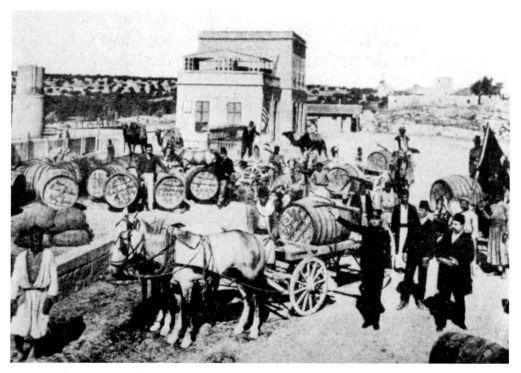

Loading the water barrels for transport to the United States at the Jerusalem train station. Note the U.S. military officer in the front and the American flag in the background center, 1906. (*Sorbonne, Open Edition Books*)

purification center. . . . The water, more than 34 tons of it in the initial shipment, was boiled, cooled, and poured into the casks from large cauldrons."

Did the water ever arrive? Was there ever a second shipment? We don't know. But today "Holy Water from the Jordan" can be purchased on eBay for between $6.25 and $12.95 per bottle.

Who Was the U.S. Diplomat Selah Merrill?

Merrill was a minister, theologian, scholar of Biblical Hebrew, archeologist, and a spiteful anti-Semite. He served as consul general in Jerusalem during the course of three decades: 1882–1885; 1891–1893; and 1898–1907 for a total of 16 years.

In 1891, 400 prominent Christians across the United States signed the "Blackstone Memorial," petitioning President Benjamin Harrison to consider a Jewish homeland for the Jews. They argued, "It is their home, an inalienable possession, from which they were expelled by force."[3]

Merrill had no patience for such Protestant restorationist "schemes." He reported to the State Department, that the appeal was "one of the wildest schemes brought before the public. [The drafters] appear to be ignorant of two great facts, (1) that Palestine is not ready for the Jews and (2) that the Jews are not ready for Palestine."[4]

Merrill biographer, Shalom Cohen, wrote, "Merrill was in the unique position of being able to respond negatively to Jewish immigration, to oppose Jewish settlement, and to shape State Department attitudes towards these settlement efforts."[5] Cohen also suggested that Merrill supported Turkish efforts to block Jewish settlement in Palestine.

Merrill split his wrath between Jews and the (new) American Colony group

WATER FROM THE JORDAN

Will be Used to Baptize Americans— Kentuckian at Head of Enterprise.

Alexandria, Egypt, Sept. 17.— Col. Clifford E. Nadaud, of Covington, Ky., president of the International River Jordan Water Company, has just arrived from Constantinople, where he obtained from the Turkish Government the sole right of shipping the water of the Jordan river from the banks of the stream in Palestine to all parts of the world for baptismal and other purposes.

He is now proceeding to the sacred river by the Jerusalem route.

The water will be shipped in casks bearing the seals of the Turkish Government and the American Consul.

The water will be bottled in the United Stated in bonded warehouses. The first shipment will go in a month.

Kentucky news article about the Jordan River water. From *The Bee*, Earlington, KY September 20, 1906. (*Kentucky Digital Library*)[i]

that established itself in Jerusalem in 1881. The Colony's liberal Protestant beliefs were blasphemy to Merrill. Their restorationist support for Jews returning to the Holy Land was sacrilege. Merrill cabled reports to the State Department accusing the Colony of immoral practices. While conducting

3. Blackstone Memorial Petition. https://en.wikisource.org/wiki/Blackstone_Memorial
4. Shalom Goldman, *The Holy Land Appropriated: The Careers of Selah Merrill, Nineteenth Century Christian Hebraist, Palestine Explorer, and U.S. Consul in Jerusalem* (American Jewish History, June 1997).
5. Ibid.

Selah Merrill, circa 1865. (*Shapell Manuscript Foundation*)[ii]

an archeological dig in Jerusalem, Merrill dug up a cemetery belonging to the American Colony, and, according to the family, scattered the bones of the movement's founder, Horatio Spafford.

In March 1906, the American Colony responded with a letter of protest to President Theodore Roosevelt (on display at the Library of Congress' online site.) The American diplomat "slandered [the Colony] in the vilest manner,"[6] refused to represent them as American citizens, and sabotaged their commercial efforts, the Colony complained; they detailed Merrill's desecration of the Jerusalem cemetery.

By 1906, an ill Selah Merrill was on his way out of his diplomatic career. He had alienated Protestants who supported the American Colony, Jews who were infuriated by his antipathy, and Christian supporters of the Zionist idea. His legacy of opposition to Jewish settlement of the Holy Land, however, was honored inside the State Department for decades.

6. Library of Congress manuscripts, "Letter to President Theodore Roosevelt." *http://www.loc .gov/exhibits/americancolony/amcolony-holyland.html#obj19*

16 Why an American Flag Flew on a Jerusalem Steamroller 100 Years Ago

T HE LIBRARY OF CONGRESS ARCHIVES INCLUDES TWO PHOTOGRAPHS of a steamroller on the streets of Jerusalem. No explanation was given for the American flag; nor was a definitive date provided.

Research revealed that the pictures were taken prior to World War I; no other motorized vehicles were on the road.

Tom Powers explained in his book, *Jerusalem's American Colony and Its Photographic Legacy*, where the steamrollers came from:

> Over the years the local Turkish functionaries frequently consulted the American Colony on matters of civic improvement, and sometimes gave them outright charge of various projects. . . . They helped bring the first steamroller to Jerusalem for upgrading the city's roads—the machine, not surprisingly, came from Chicago! [The founders of the American Colony came from Chicago.][1]

In response to my inquiry about the road machine, the webmaster of the British Road Roller Association responded, "My colleagues have responded that this is not a Steam Roller; it's an American-built Austin motor roller with two somewhat narrow flywheels (in the style of much later A&P motor rollers.) It's thought to be from around the time of WWI."[2]

1. Tom Powers, "Jerusalem's American Colony and Its Photographic Legacy, 2009," https://israelpalestineguide.files.wordpress.com/2009/12/jerusalems_american_colony-_its_photographic_legacy.pdf
2. Private email correspondence between the author and the webmaster of the British Road Roller Association, June 25, 2012.

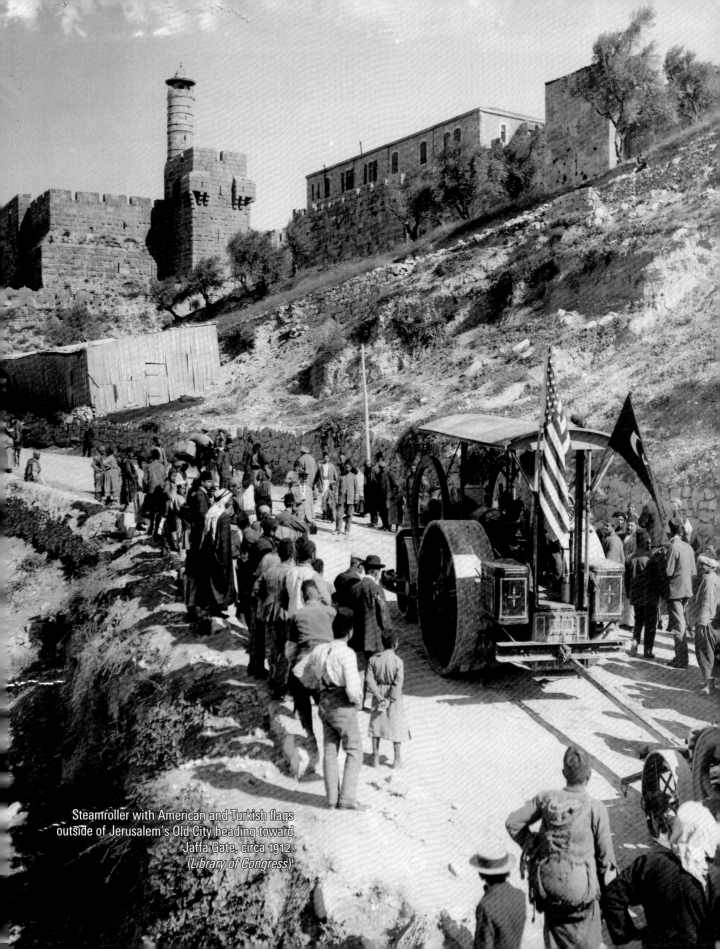

Steamroller with American and Turkish flags outside of Jerusalem's Old City heading toward Jaffa Gate, circa 1912. (*Library of Congress*)[i]

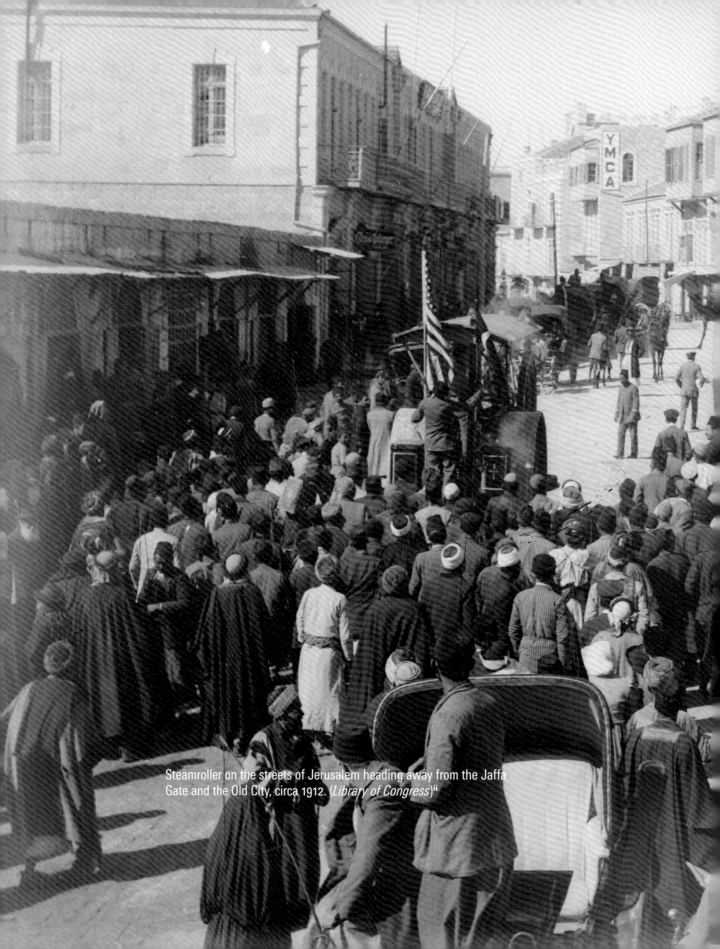

Steamroller on the streets of Jerusalem heading away from the Jaffa Gate and the Old City, circa 1912. (*Library of Congress*)[ii]

17 Americans and Canadians Join the War to Liberate Palestine in 1917

T HE EFFORTS OF JEWS TO DEFEND THEMSELVES IN PALESTINE IN THE 20th century can be traced back to the self-defense cells set up in the early 1900s by groups calling themselves *Bar Giora* and *HaShomer*. When World War I broke out in the Middle East, Russian Zionist activists Zeev Jabotinsky and Joseph Trumpeldor – who had been expelled from Palestine by the Turks – lobbied the British army to establish a Jewish unit. The Zion Mule Corps was formed in Egypt in 1915 and dispatched to Gallipoli where the 560 Jewish soldiers saw action as a transport unit.

The Zion Mule Corps was disbanded in 1916, but by 1917, the British army approved the formation of five battalions into the Jewish Legion, made up of volunteers from Palestine, Britain, Russia, Canada, and the United States. Many of the Russian volunteers were Zionist immigrants living in Israel who were among the 6,000 expelled by the Turks in 1914–1915 and evacuated by the U.S. Navy to Alexandria, Egypt. By some accounts, 11,000 men served in the Legion over the course of the war – 34 percent came from the United States, 30 percent came from Palestine, 28 percent from Britain, and six percent from Canada.[1]

1. Lenni Brenner, "The Iron Wall," https://archive.org/stream/TheIronWall-ZionistRevisioni smFormJabotinskyToShamir/Ironw_djvu.txt

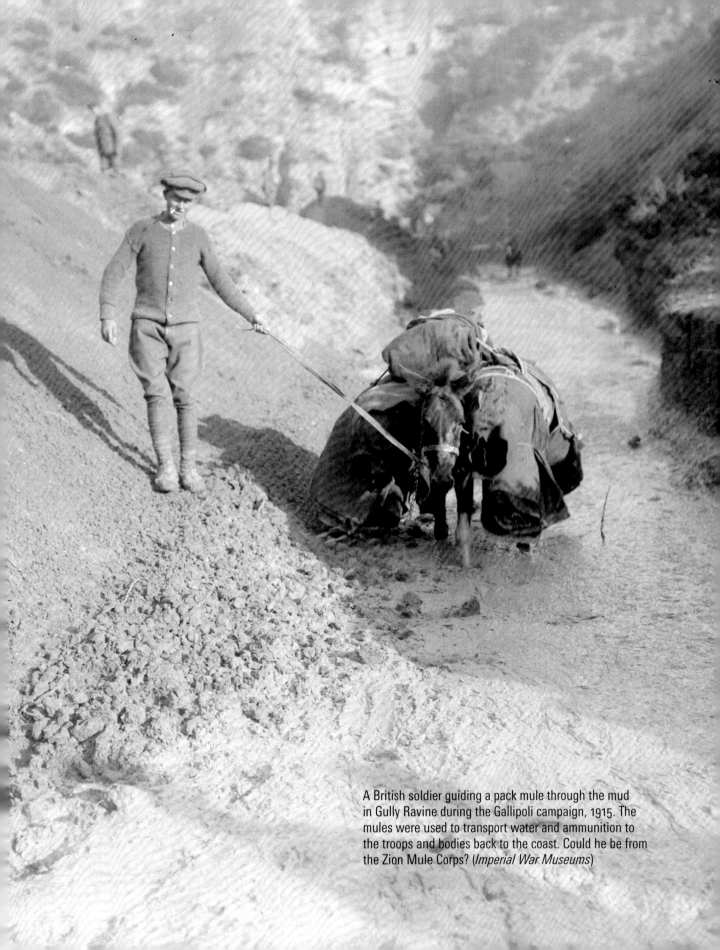

A British soldier guiding a pack mule through the mud in Gully Ravine during the Gallipoli campaign, 1915. The mules were used to transport water and ammunition to the troops and bodies back to the coast. Could he be from the Zion Mule Corps? (*Imperial War Museums*)

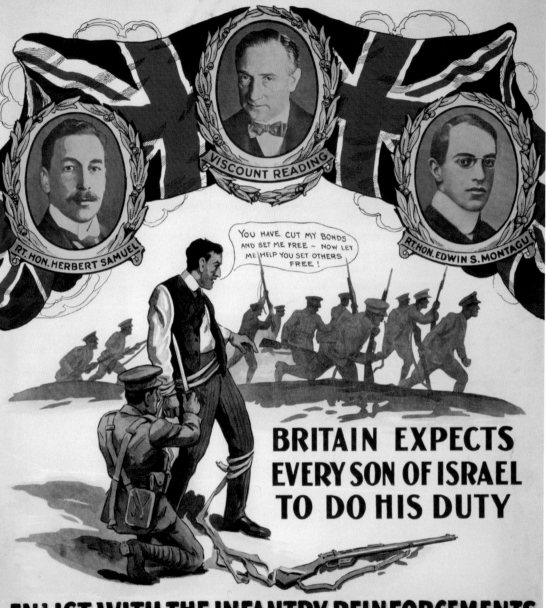

Recruiting posters in Canada in English and Yiddish, circa 1918. (*Library of Congress*)[i]

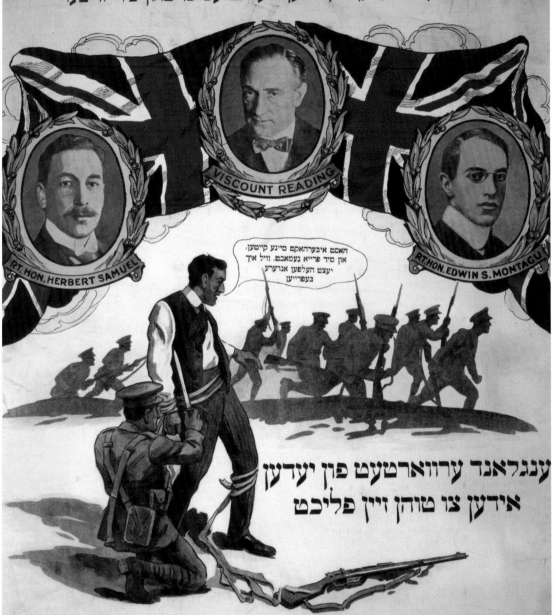

די אידען פון דער גאנצער וועלט שטרעבען צו פרייהיים, האבען זיך
דאפיר מקריב געווען, און זיינען בערייט עס צו טהון פיר וויטער

ענגלאנד ערווארטעט פון יעדען
אידען צו טהון זיין פליכט

פערשרייבט אייך מיט דער אינפאנטערי ריענפארסמענט

אונטער דער לייטונג פון

קאפטיין איזידאר פרידמאן

הויפט קוואדערם

786 סט. לאורענם בולוווארד מאנטרעאל

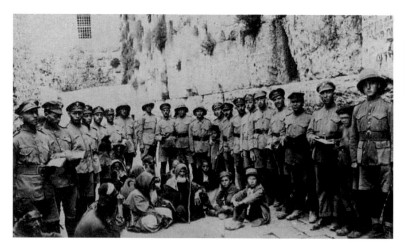

Members of the Jewish
Legion at the Western
Wall, probably in 1918.
(*Wikipedia*)[ii]

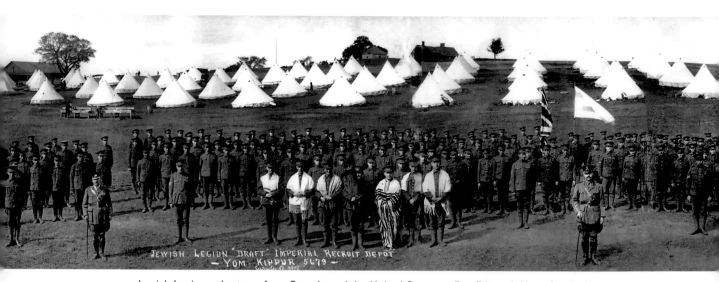

Jewish Legion volunteers from Canada and the United States at Fort Edward, Nova Scotia, Yom
Kippur, 1918. (*Wikipedia*)[iii]

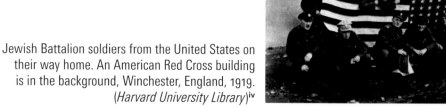

Jewish Battalion soldiers from the United States on
their way home. An American Red Cross building
is in the background, Winchester, England, 1919.
(*Harvard University Library*)[iv]

18 Getting to Know the Jewish Legionnaires from 100 Years Ago: David Blick of Brooklyn and Leon Cheifetz of Montreal

ACCORDING TO ZEV JABOTINSKY,[1] AN ESTIMATED 5,000 AMERICAN and Canadian Jews volunteered to fight in the Jewish Legion in the ranks of the British army in Palestine during World War I. The new recruits to the Jewish Legion were considered heroes in their communities. "Carrying the Jewish flag," author Nancy Gentile Ford wrote, "the first group of 150 recruits paraded down Fifth Avenue [in New York City] to the sounds of a military band. Thousands of supporters turned out to celebrate the event."[2]

"Within a few weeks, another squad, this time with 350 Jews from New York, Philadelphia, and Cleveland marched through the Bronx after being sworn into the British Army," Ford continued. "Jewish legionnaires from Chicago, Baltimore, Syracuse, Newark and small towns in Connecticut and New Jersey soon joined other Jewish Americans to fight for Palestine."[3]

The support for the American Jewish volunteers was so strong that Con-

1. Vladimir Jabotinsky, *The Story of the Jewish Legion*, 1945.
2. Nancy Gentile Ford, *Americans All!: Foreign-born Soldiers in World War I*, (Texas A&M University Press, 2008) https://books.google.co.il, http://tinyurl.com/gmn7uh8
3. Nancy Gentile Ford, *Americans All!: Foreign-born Soldiers in World War I*, (Texas A&M University Press, 2008) https://books.google.co.il, http://tinyurl.com/gmn7uh8

gress passed a law to ease their return to the United States after their service.[4]

The romanticized image of the Jewish warriors was a stimulant for American Jews, according to Arthur Hertzberg, author of *The Jews in America*. "American Jews received a glorious sense of their own power and of their participation in the renaissance of Jewish power in the land of their ancestors."[5]

The stories and photographs of two soldiers, Leon Cheifetz of Montreal and David Blick of Brooklyn, present a fascinating look into the lives of the Jewish volunteers who fought in Palestine.

Upon returning to Canada after the war, Cheifetz assembled an album with dozens of pictures and biographies of many of the Canadians who fought with him.[6] The biographies show that most of the volunteers were born in Russia, Poland, Rumania, Austria, and other eastern European countries and had immigrated to Canada with their families. Belonging to Zionist organizations in Canada, they clearly sought a solution in Palestine for the "wandering Jew." Some of the soldiers stayed in the Holy Land after the war and established families.

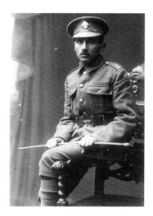

Private David Blick's photo postcard to his family (in Yiddish), 1918. (*Courtesy of the Blick family*)

David Blick's story and photographs were provided by his descendants, Yakov Marks and his wife, Rena Chaya Brownstein Marks. David served in the British army in Palestine between April 8, 1918 and March 18, 1920. "While camped in the area of Rishon LeZion," wrote his descendant Yakov, "David met and later married Rachel Churgin of Yaffo. They were forced to leave Eretz Yisrael by the British [after the war]."

The wartime experiences of the Jewish battalions were not as attractive and noble as imagined by the young recruits and their adoring fans. The units arrived in 1918 after the capture of Jerusalem; their duties were often

4. *Daily Jewish Courier*, June 20, 1918, http://flps.newberry.org/article/5423972_4_1_0448
5. Arthur Hertzberg, *The Jews in America: Four Centuries of an Uneasy Encounter* (Columbia University Press, 1997).
6. "Album of the Jewish Legion," Jewish Public Library, http://www.jewishpubliclibrary.org/blog/wp-content/uploads/2010/11/JEWISH-LEGION.pdf

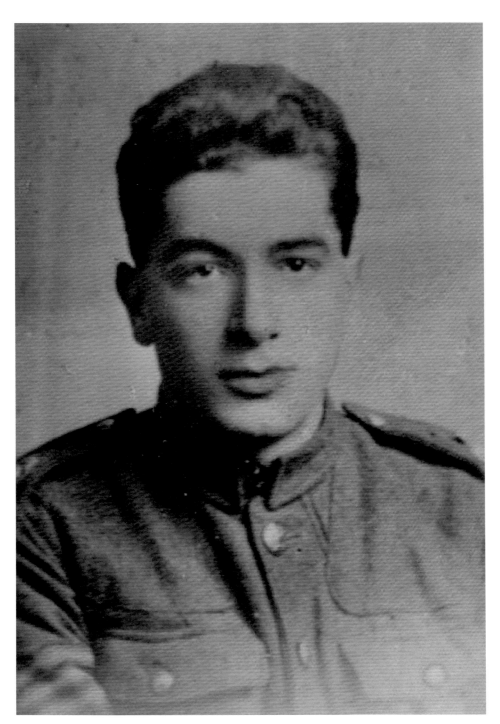

Sergeant Leon Cheifetz. (*Cheifetz* Album of the Jewish Legion)

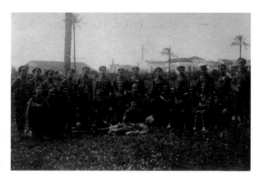

Pvt. David Blick's Jewish Legion unit in
Palestine, circa 1919.
(*Courtesy of the Blick family*)

in support roles such as guarding prisoners. Conditions in the field were
horrendous, and the anti-Semitism expressed by fellow soldiers and high of-
ficers was infuriating. The Jewish soldiers did see combat in the Galilee and
Transjordan. The letters and diaries of the Legionnaires in *We Are Coming,
Unafraid* by Michael Keren and Shlomit Keren,[7] make for fascinating reading.

More information on the Jewish Legion can be viewed at the Beit Hagdu-
dim (Jewish Legion Museum) near the city of Netanya, Israel.[8]

Blick's unit, apparently meeting with Jewish
farmers in Rishon LeZion, circa 1918–1919.
(*Courtesy of the Blick family*)

7. Michael Keren and Shlomit Keren, *We Are Coming, Unafraid: The Jewish Legions and the
 Promised Land in the First World War* (Rowman and Littlefield Publishers, 2010).
8. Beit Hagdudim, http://eng.shimur.org/gdudim/

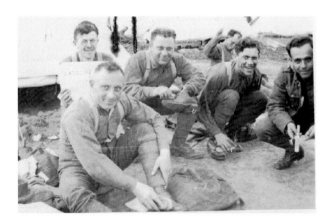

Jewish soldiers shining boots at the front. Note the Hebrew or Yiddish newspaper, circa 1918. (*Cheifetz Album*).

Caption in Yiddish: *"A group from the 39th battalion with workers and children from Ben-Shemen."* The sign bears the Biblical verse (*Leviticus 19:23*) "When you reach the Land and you plant. . . ." Apparently photographed on the planting holiday of Tu B'Shvat, in 1919. (Cheifetz Album)

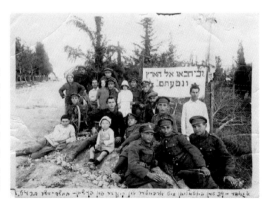

19 The U.S. Navy Saved the Jews of the Holy Land 100 Years Ago

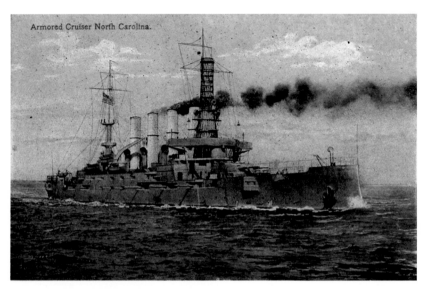

USS North Carolina, 1905. (*Photographic History of the U.S. Navy*)[i]

N THE EARLY 1900S, THE JEWS OF PALESTINE SUFFERED TERRIBLY FROM hunger, disease, and oppression. The territory was ruled with an iron fist by the Ottoman (Turkish) army. The Middle East was aflame in "the Great War" – World War I. At the start of the war in 1914, Turkey abolished the "capitulation" agreements with European powers, which granted them elements of sovereignty over their subjects in the Ottoman Empire. The financial assistance the Jews received from their European Jewish brethren evaporated. For many Jews of the Holy Land, their French, British, and Russian protectors were gone, and they were seen as citizens of the enemy. The Turkish authorities ordered their immediate expulsion.

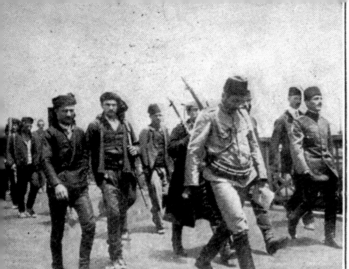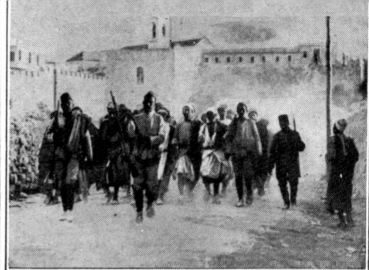

servists and recruits rounded up in Palestine by the Turks being marched unwillingly to barracks. Right : Troops of the Turkish Regular Army marching newly-raised levies through Jerusalem to a camp in readiness for their projected attack on Egypt.

The forced conscription and looting of Jerusalem homes, 1914. (*Ottoman Imperial Archives*)[ii]

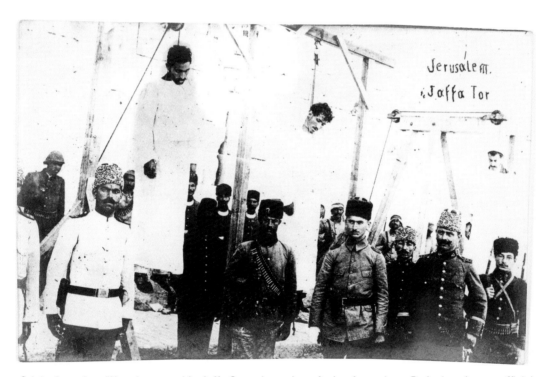

Original caption: "Hangings outside Jaffa Gate, Jerusalem. Arabs, Armenians, Bedouins, Jews – official Turkish photo." The script on the photo appears to be Germanic, circa 1915–1917. (*Mitchell Library, State Library of New South Wales, Australia*)[iii]

Another early step taken by Turkey in World War I was the massing of troops in Palestine and the Sinai to move against the British along the Suez Canal. The Turkish army prepared for the attack by forcibly conscripting locals, including Jews, and by looting (so-called "levies") of supplies, food, and animals from residents of Palestine. Citizens of Palestine deserting or avoiding the draft were subject to hanging. Rare photographs taken from captured German officers during the war showed the executions.

The Threat from Above

In March 1915, the situation for the residents of Palestine turned even more hopeless when a plague of locusts of Biblical proportions ravaged the land for six months. The Turkish authorities demanded that every man had to collect 20 kilos (44 pounds) of locusts.

The United States retained its neutrality during the war until 1917. Its consulate in Jerusalem, headed by Dr. Otis Glazebrook, remained open. The Americans were the only ones left to help the Jews of Palestine.

On August 31, 1914, the American ambassador to Turkey, Henry Morgenthau, sent an urgent telegram to the New York Jewish tycoon Jacob Schiff. "Palestinian Jews facing terrible crisis," he wrote.

"Belligerent countries stopping their assistance[.] Serious destruction threatens thriving colonies[.] Fifty thousand dollars needed by responsible committee[.] Dr. Ruppin chairman to establish loan institute and support families whose breadwinners have entered army[.] Conditions certainly justify American help. Will you undertake matter[?]" [Signed] "Morgenthau."

Realizing the difficulty in bringing money into Palestine past corrupt Turkish officials, Morgenthau also appealed to Secretary of State William Jennings Bryan for assistance. It came in the form of U.S. Navy ships.

The U.S. Navy to the Rescue

On October 6, 1914, the U.S. Navy's USS North Carolina landed in the Jaffa harbor and delivered $50,000 to the U.S. consul general for distribution to

WESTERN UNION

ANGLO-AMERICAN DIRECT UNITED STATES

CABLEGRAM

NEWCOMB CARLTON, PRESIDENT
GEORGE W. E. ATKINS, VICE-PRESIDENT BELVIDERE BROOKS, VICE-PRESIDENT

Form 2875

Received at 16 BROAD STREET, NEW YORK

A 18/31K D

1914 AUG 31 AM 6 19

D 100

YENIKEUY 50

JACOB SCHIFF

NEWYORK

PALESTINIAN JEWS FACING TERRIBLE CRISIS BELLIGERENT COUNTRIES STOPPING

THEIR ASSISTANCE SERIOUS DESTRUCTION THREATENS THRIVING COLONIES FIFTY

THOUSAND DOLLARS NEEDED BY RESPONSIBLE COMMITTEE DR RUPPIN CHAIRMAN

TO ESTABLISH LOAN INSTITUTE AND SUPPORT FAMILIES WHOSE BREADWINNERS

HAVE ENTEROD ARMY CONDITIONS CERTAINLY JUSTIFY AMERICAN HELP WILL YOU

UNDERTAKE MATTER

MORGENTHAU

Morgenthau's cable to Schiff, 1914. (*JDC Archives*)

Locust eradication attempt, 1915. (*Library of Congress*)

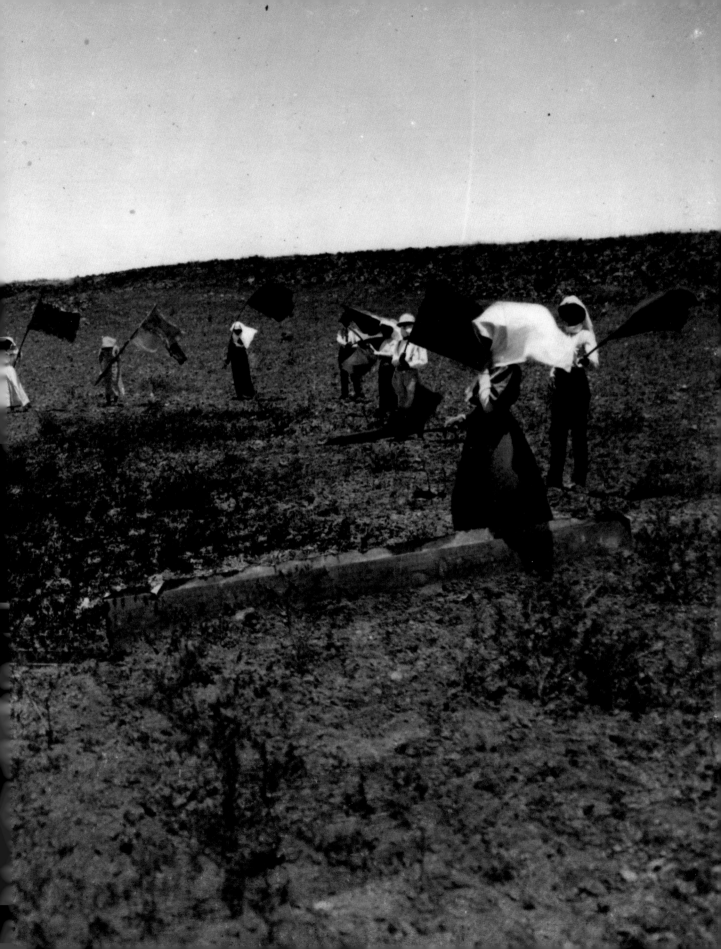

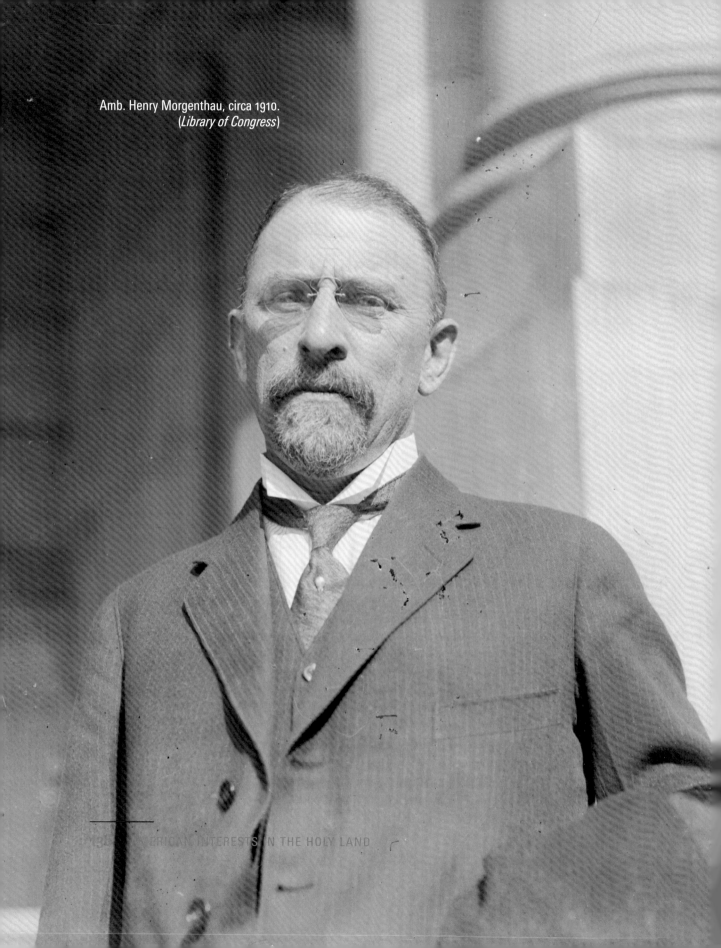

Amb. Henry Morgenthau, circa 1910.
(*Library of Congress*)

United States Navy Yards

Portsmouth, Va. February 2ᵗʰ 1916

Received on Board U·S·S·STERLING

Eighty-Two (82) Cases and Casks - Tonnage Twelve Thousand (12 000) Lbs.

Medicines, Drugs and Chemicals

Marks: American Consul Alexandria, Egypt

(Further instructions to follow)

☆

Forwarders: The Joint Distribution Committee of New York
For Jewish Relief.

Hayne Ellis
Commander

Receipt from the U.S. Navy for emergency supplies for the Jews of Palestine, 1916. (*JDC archives*)

the Jewish community. A total of 13 port visits were made by ships such as the USS *North Carolina, Vulcan, Des Moines, and Tennessee* which plied the eastern Mediterranean between Beirut and Cairo. Some of the ships delivered money, food, and aid to the Jews of Palestine until the United States entered the war in 1917.

According to one report, 23,000 people in Jerusalem "received an allotment of food from just one ship in 1915."[1]

In early 1915, the U.S. Secretary of the Navy Josephus Daniels reacted to concerns of epidemic and famine among the Jewish communities in Palestine. "Daniels dispatched the U.S. Navy ship *Vulcan* with some 900 tons of foodstuffs and medicine," including food and matzot for the Passover

1. Michael Brown, *The Israeli American Connection: Its Roots in the Yishuv, 1914–1945* (Wayne State University Press, 1996).

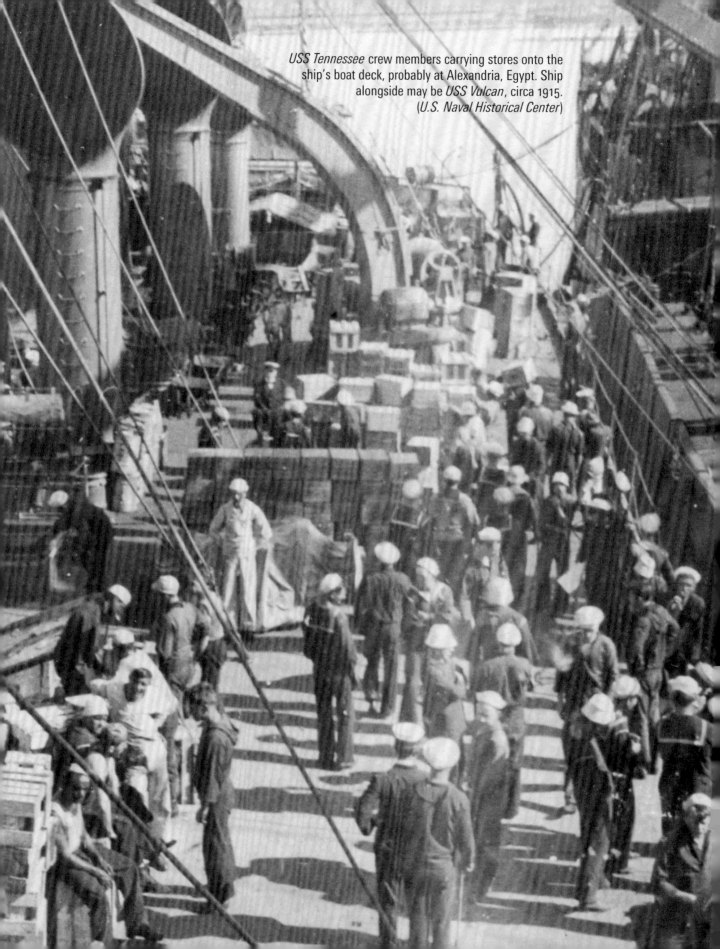

USS Tennessee crew members carrying stores onto the ship's boat deck, probably at Alexandria, Egypt. Ship alongside may be *USS Vulcan*, circa 1915. (*U.S. Naval Historical Center*)

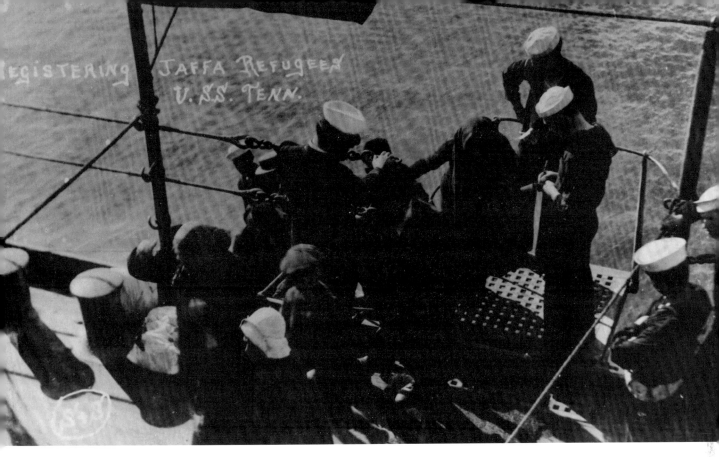

Registering World War I refugees as they came on board at
Jaffa, Palestine, circa February 1915.
(*U.S. Naval History and Heritage Command*)[iv]

World War I refugees from Jaffa, Palestine, leaving the ship at
Alexandria, Egypt, February 14, 1915.
(*U.S. Naval History and Heritage Command*)[v]

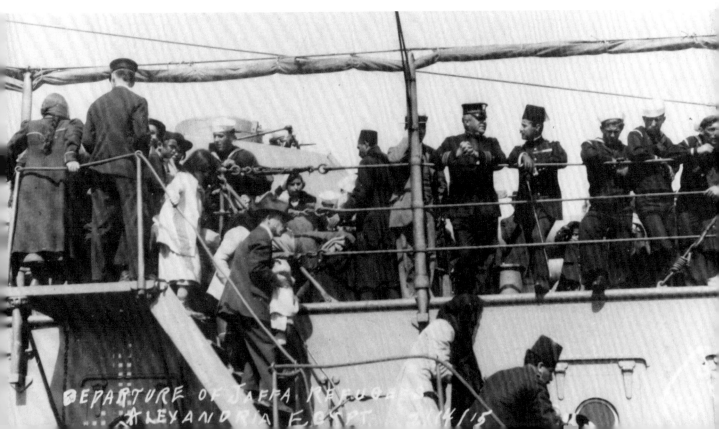

holiday, according to *FDR and the Jews* by Richard Breitman.[2] "Race across the ocean," Daniels instructed the captain, in order to arrive before the holiday.

Carrying the Human Cargo

The U.S. ships also departed the Holy Land with valuable cargo – the Jews of Palestine who were expelled or had to flee the Turks because of their Russian origins, Zionist activity, or draft dodging. One such Palestinian Jew was Alexander Aaronsohn whose brother Aaron and sister Sarah were founders of the anti-Turk NILI spy network that assisted the British. Sarah Aaronsohn killed herself after prolonged Turkish torture.

Approximately 6,000 Jews of Palestine were evacuated by U.S. Navy ships in 1914 and 1915, according to naval historian Andrew C.A. Jampoler, a frequent contributor to Naval Institute Press.[3] "According to type-written manifests attached to her deck log," Jampoler wrote, "between December 1914 and June 1915, *Tennessee* [*alone*] transported seven ship-loads of stricken refugees."

In his book *With the Turks in Palestine*, Alexander Aaronsohn relates: "One of the American cruisers, by order of Ambassador Morgenthau, was empowered to assist citizens of neutral countries to leave the Ottoman Empire. These cruisers had already done wonderful rescue work for the Russian Jews in Palestine, who, when war was declared, were to have been sent to the Mesopotamian town of Urfa—there to suffer massacre and outrage like the Armenians."[4]

Aaronsohn stealthily traveled to Beirut where he was able to sneak aboard the *USS Des Moines*. Once under sail, Aaronsohn wrote, "Friends discovered friends and tales of woe were exchanged, stories of hardship, injustice, oppression, all of which ended with mutual congratulations on escaping from the clutches of the Turks."

2. Richard Breitman, *FDR and the Jews* (Harvard University Press, 2013).
3. Andrew C. A. Jampoler, "The Guns of August and the 1914 European Cruise of USS Tennessee (ACR-10)," http://jampoler.com/wp-content/uploads/2015/09/The-Guns-of-August-1914-and-the-Cruise-of-the-Armored-Cruiser-USS-Tennessee.pdf
4. Aaron Aaronsohn, *With the Turks in Palestine*, 1916, eBook, http://www.gutenberg.org/ebooks/10338, http://www.gutenberg.org/files/10338/10338-h/10338-h.htm

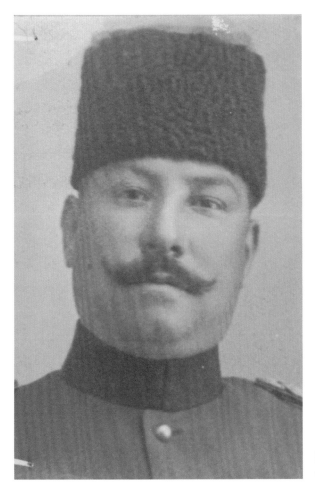

Hassan Bey, the "Tyrant of Jaffa," 1917. (*Library of Congress*)[vi]

Hardship under the Turks

One Turkish official responsible for the hardship, injustice, and oppression was Hassan Bey.

In a 1921 report on the Jews of Palestine in World War I,[5] the Zionist Organization of London related, "The harshest and most cruel of all the Turkish officials was the Commandant of the Jaffa district, Hassan Bey."

5. "*Palestine during the war: being a record of the preservation of the Jewish settlements in Palestine,*" (London Zionist Organization, 1921), http://www.archive.org/stream/palestineduringw00 lond/palestineduringw00lond_djvu.txt

The report described how "it would suddenly come into his head to summon respectable householders . . . with an order to bring him some object from their homes which had caught his fancy or of which he had heard — an electric clock, a carpet, etc. Groundless arrests, insults, tortures, bastinado [clubs]-these were things every householder had to fear."

In April 1917, on the eve of Passover, the Turks ordered the expulsion of approximately 10,000 Jews from Jaffa.[6] An estimated 23 percent died of hunger, cholera, dysentery, and pneumonia. The Turks' expulsion of all Jews from Palestine was halted by the German commanders in Palestine.[7]

The Jews of the Holy Land "would have succumbed had not financial help arrived from America," the Zionist Organization of London report declared. "America was at that time the one country which through its political and financial position was able to save [Jewish] Palestine permanently from going under."[8]

When the British entered Jerusalem in December 1917 they found 2,700 orphans, the report stated.

The first British military governor, Ronald Storrs, arrived in the city and wrote in his diary of "many ladies of doubtful reputation . . . On our entry into Jerusalem, we had found no less than 500 such women living in a special quarter." Storrs sent as many of them as possible back to their "places of origin" and "abolished the quarter."[9]

6. Gur Alroi, *Expelled in Their Own Land? The episode of Tel Aviv and Jaffa's expelled Jews in the Lower Galilee, 1917–1918, http://www.ybz.org.il/_Uploads/dbsAttachedFiles/Article_120.6.pdf*

7. Lenny Ben-David, "*Did a German Officer Prevent the Massacre of the Jews of the Holy Land during World War I?*", Israel Daily Picture, http://www.israeldailypicture.com/2014/05/chapter-world-war-i-did-german-officer.html

8. "*Palestine during the war: being a record of the preservation of the Jewish settlements in Palestine,*" (London Zionist Organization, 1921), http://www.archive.org/stream/palestineduringw00lond/palestineduringw00lond_djvu.txt

9. Dalia Karpel, "Discerning Conqueror" (*Haaretz*, November 12, 2010), http://www.haaretz.com/israel-news/discerning-conqueror-1.324306

20 U.S. Diplomat Saved Jews in 1915 but Opposed the Zionist Idea in 1920

THE AMERICAN CONSUL GENERAL IN JERUSALEM, DR. OTIS GLAZEBROOK, served in the critical years surrounding World War I (1914–1917 and 1919–1920). He was a former missionary and personal friend of President Woodrow Wilson. At the start of his tenure, Palestine was part of the Ottoman Empire, and the Jerusalem consul played an ambassador's role.

During World War I and prior to the United States entering the war, Glazebrook used his position in Jerusalem to protect Jews from local Turkish tyrants and to disburse money from the American Jewish community to Jewish indigents in the Holy Land (requested by U.S. Ambassador to the Ottoman Court, Henry Morgenthau; see Chapter 19 – The U.S. Navy Saved the Jews of the Holy Land 100 Years Ago). Without Glazebrook's intercession and the delivery of the funds and supplies on U.S. Navy ships, the aid would probably have been stolen by Turkish officials and would never have been delivered to the Jews of Palestine. In a 1931 obituary for the diplomat, the *JTA* reported, "Dr. Glazebrook distributed Jewish relief funds in Jerusalem during the war, for which he received high praise from Jewish leaders in the United States."[1]

1. "Death of U.S. Consul in Jerusalem Who Distributed Jewish Relief Funds During War," *Jewish Telegraphic Agency*, May 12, 1931, http://www.jta.org/1931/05/12/archive/death-of-u-s-con sul-in-jerusalem-who-distributed-jewish-relief-funds-during-war, http://tinyurl.com/jax dsps

Glazebrook (center, in top hat) and his Jerusalem Consulate staff, 1914. (*Virginia Military Institute Archives*)

Alexander Aaronsohn described his contacts with Glazebrook in his book *With the Turks in Palestine*. Aaronsohn's family was involved in the Jewish NILI spy ring against the Turks, and Alexander was forced to escape a Turkish dragnet by slipping away on an American navy ship. "Consul Glazebrook . . . is a true American," Aaronsohn wrote. "He was most earnest and devoted in behalf of the American citizens that came under his care . . . He was practically the only man who stood up for the poor, defenseless people of [Jerusalem]."[2] (For more on Aaronsohn's account, see Chapter 19 – The U.S. Navy Saved the Jews of the Holy Land 100 Years Ago.)

2. Alexander Aaronsohn, *With the Turks in Palestine*, 1916, eBook, http://www.gutenberg.org /ebooks/10338 , http://www.gutenberg.org/files/10338/10338-h/10338-h.htm

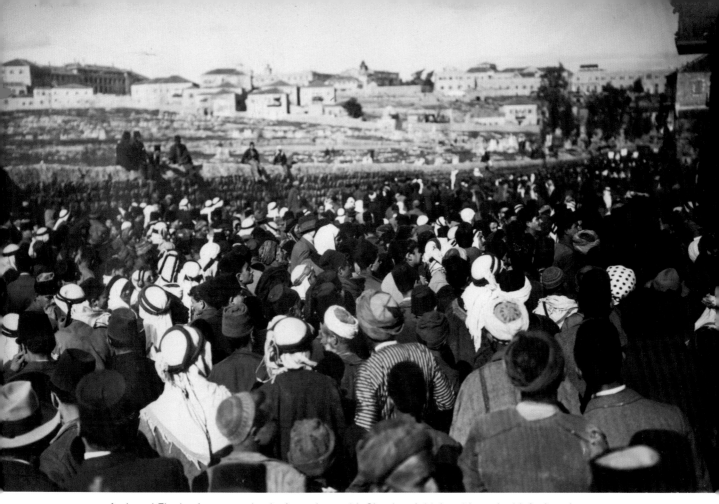

Arab anti-Zionist demonstration in Jerusalem, with Glazebrook (right with top hat) lofted on the demonstrators' shoulders, February 1920. (*Library of Congress*)

A Different Man after the War

After the war, Glazebrook returned to his diplomatic post, but Palestine was a different place, now under the rule of the British Mandatory Authority. Jewish refugees from war-torn Europe were arriving; Zionist communities were being built across Palestine. And the Arabs in the Middle East were demanding their share of the spoils and authority of the dead Ottoman Empire, shocked that Middle East lands had already been divided up by the secret 1916 European Sykes-Picot agreement.

Arab anti-British demonstrations took on a distinct anti-Jewish/Zionist complexion, and throughout the land, attacks against Jews were common.

The Palestinian Arabs' anti-Zionist demonstrations were not a one-time

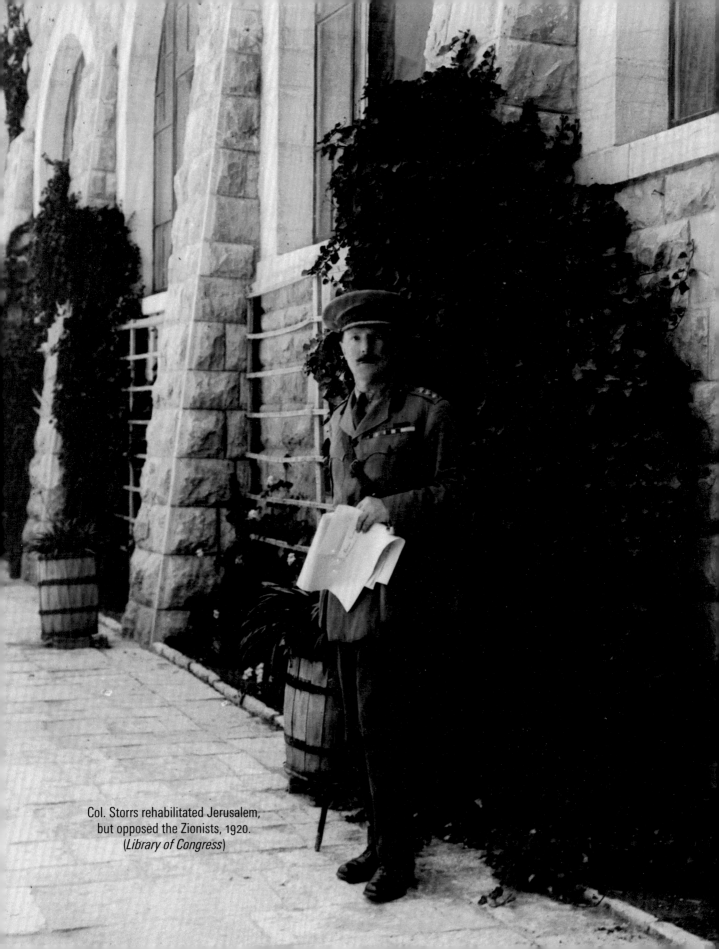

Col. Storrs rehabilitated Jerusalem,
but opposed the Zionists, 1920.
(*Library of Congress*)

occurrence in 1920. There were several such demonstrations in February, March, and April 1920. The latter, held during the week-long Nebi Musa festival, turned into an anti-Jewish pogrom.

Several senior officials of the British Mandate, including Col. Ronald Storrs, the military governor of Jerusalem and Judea (1920–1926), were strongly opposed to the Balfour Declaration. Col. Richard Meinertzhagen, a senior British officer supportive of the Zionist enterprise, suspected some of his army colleagues were actually encouraging the Arab attacks.[3]

The British anti-Zionists found a sympathetic ally in the U.S. Consul-General to Jerusalem, Dr. Otis Glazebrook.

In his secret cables to the State Department, Glazebrook was vehement in his opposition to the Zionist enterprise. According to findings of researcher Yisrael Medad, the Consul warned in 1919 that local opposition to Zionism was "real, intense, and universal. . . . Any importation of Zionists would be met by force of arms." Glazebrook also accused Jews of threatening to destroy the Church of the Holy Sepulcher.[4]

Glazebrook's opposition to the Jewish rebuilding of the land of Israel may have reflected his missionary background, but it also expressed an attitude prevalent in the U.S. State Department – before and after Glazebrook.

3. Colonel R. Meinertzhagen, *Middle East Diary, 1917 to 1956* (Cresset Press, 1959).
4. Yisrael Medad, *My Right Word*, "Praise but Beware of American Consuls-General," December 12, 2010, http://myrightword.blogspot.co.il/2010/12/praise-but-beware-of-american-consuls.html

21 Chief Rabbi of Palestine Goes to the White House, 1924

RABBI ABRAHAM ISAAC KOOK (1865–1935) WAS A RENOWNED TALMUD scholar, Kabbalist, and philosopher. Today he is considered the spiritual father of religious Zionism, having broken away from his ultra-Orthodox colleagues who were opposed to the largely secular Zionist enterprise.

Born in what is today Latvia, Rabbi Kook moved to Palestine in 1904 to take up the post of Chief Rabbi of Jaffa. He appears in many of the historic pictures taken by the American Colony photographers, usually as a bystander, without being identified. One photograph, found in the Library of Congress' collection, identifies the rabbi, but the surroundings do not appear to be in the Land of Israel and actually look incredibly like a street scene in the United States.

For good reason: the picture was taken in Washington D.C. on April 15, 1924, when Rabbi Kook met with President Calvin Coolidge in the White House.

Coolidge was in Washington on that day when Rabbi Kook's photo was taken. Coolidge's calendar records him throwing out the first ball at a Washington Senators baseball game where Walter Johnson shut out the Athletics. Rabbi Kook's meeting does not appear on the calendar, according to the Coolidge library.

The picture of the rabbi appears in the Library of Congress archives in a large set of unaccredited pictures taken that week of well-known Washington politicians, including Coolidge, the White House press corps, Senate leaders William Borah and Burton Wheeler, the Federal Oil Reserve Board, and more.[1]

1. Gallery, Library of Congress Prints and Photographs, http://www.loc.gov/pictures/related/?&pk=npc2008006095&st=gallery&sb=call_number#focus

But why was the rabbi in the United States? What was the rabbi doing in Washington, and why did Coolidge meet him?

According to an article by Joshua Hoffman, *Rav Kook's Mission to America*,[2] Rabbi Kook, then Chief Ashkenazi Rabbi in Palestine, headed a delegation of rabbis to the United States in March 1924 to raise funds for *yeshivot* in Europe and Palestine. He was joined by Rabbi Moshe Mordechai Epstein, the head of the Slabodka yeshiva in Lithuania, and Rabbi Avraham Dov Baer Kahana Shapiro, the Rabbi of Kovno and president of the Rabbinical Association of Lithuania. The three rabbis were brought to America by the Central Committee for the Relief of Jews Suffering through the War, better known as the Central Relief Committee (CRC).

Rabbi Kook's boat was met in New York Harbor by hundreds of Jewish leaders. The rabbis were escorted to a meeting with New York's Mayor John F. Hylan by a "squadron" of police motorcycles and a 50-car procession.[3]

The *Canadian Jewish Chronicle* described Rabbi Kook on May 2, 1924, prior to the rabbis' visit to Montreal:[4]

> *Rabbi Kook of Palestine . . . is a man of rare mental attainments. He is a renowned theologian, poet, philosopher and humanitarian. At the age of 18 he had already several books on ethical and philosophical topics to his credit for which he received a doctorate degree from the Berne University. From his youth Rabbi Kook was enamored with the Holy Land. At the outbreak of the world war Rabbi Kook happened to be in Switzerland. Owing to his pro-ally sentiments, the Germans refused him permission to return to Palestine . . . When General Allenby liberated Palestine, Rabbi Kook returned to Palestine and was immediately elected Chief Rabbi of the Holy Land and officially installed in this high office by the High Commission, Sir Herbert Samuel. . . .*

2. Joshua Hoffman, *Rabbi Kook in America*, http://ravkooktorah.org/RAV-KOOK-IN-AMERICA .htm
3. Ibid.
4. "Rabbi Kook to Visit Montreal," https://news.google.com/newspapers, http://tinyurl.com /h2uklej

President Coolidge with baseball great Walter Johnson, April 15, 1924.
(*Library of Congress*)[i]

The conversation between the Chief Rabbi and President Coolidge is described by Hoffman in *Rav Kook's Mission to America*:[5]

> *Rabbi Kook thanked him for his government's support of the Balfour Declaration, and told him that the return of the Jews to the Holy Land would benefit mankind. Kook explained that according to the Talmudic sages, peace can only be expected when the Jews return to the Holy Land. Kook also thanked the American government on behalf of the Jews throughout the world, for its relief work during the war. He praised America for its dedication to liberty as engraved on Philadelphia's Liberty Bell: "And you shall proclaim liberty throughout the land for all its inhabitants."*

5. Joshua Hoffman, *Rabbi Kook in America*, http://ravkooktorah.org/RAV-KOOK-IN-AMERICA.htm

Rabbi Dr. Abraham I. Kook in Washington D.C. to meet President Calvin Coolidge at the White House, April 15, 1924. The photo is commonly used in Israel today, but few realize where it was taken. (*Library of Congress*) ➤

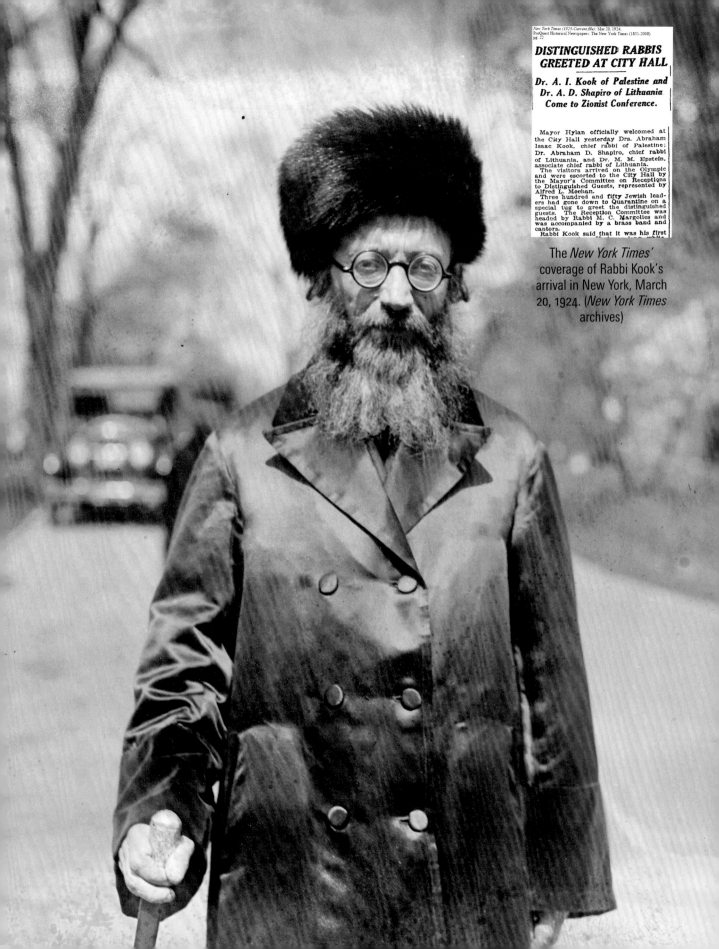

DISTINGUISHED RABBIS GREETED AT CITY HALL

Dr. A. I. Kook of Palestine and Dr. A. D. Shapiro of Lithuania Come to Zionist Conference.

Mayor Hylan officially welcomed at the City Hall yesterday Drs. Abraham Isaac Kook, chief rabbi of Palestine; Dr. Abraham D. Shapiro, chief rabbi of Lithuania, and Dr. M. M. Epstein, associate chief rabbi of Lithuania.

The visitors arrived on the Olympic and were escorted to the City Hall by the Mayor's Committee on Receptions to Distinguished Guests, represented by Alfred L. Meehan.

Three hundred and fifty Jewish leaders had gone down to Quarantine on a special tug to greet the distinguished guests. The Reception Committee was headed by Rabbi M. C. Margolies and was accompanied by a brass band and cantors.

Rabbi Kook said that it was his first

The *New York Times'* coverage of Rabbi Kook's arrival in New York, March 20, 1924. (*New York Times* archives)

Hoffman described the president's response: *Coolidge assured Kook "America would assist Jews whenever possible and acknowledged the valuable contribution of Jews in [America's] War of Independence."*

Rabbi Kook's perceptive impression of American Jewry was expressed in an interview with the *Morgen Journal:*[6]

> *Rav Kook referred to American Jewry as a hidden treasure and enumerated three qualities they had which, if developed, could make them one of the most important Jewries in history. These qualities were a deep feeling for religiosity, a sense of Jewish nationalism, and a sense of social responsibility. He attributed the last quality to the excellent human material of which the Jewish communities consist, as well as to the civil liberties enjoyed by American Jews as free citizens of a republic under a generous and democratic government. He also noted the importance of the civic education which American Jews receive through their unhampered participation in their country's political affairs.*

Rabbis Kook (right) and Moshe Mordechai Epstein (left) with the mayor of New York City, John F. Hylan, 1924.

6. Joshua Hoffman, *Rabbi Kook in America*, http://ravkooktorah.org/RAV-KOOK-IN-AMERICA .htm

22 Americans Were Outraged by the 1929 Hebron Pogrom and a U.S. Diplomat's Anti-Semitic Reaction

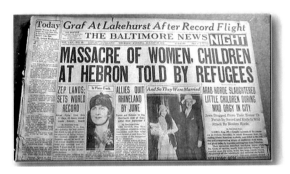

Front page news in the United States, October 2, 1929.
(*Baltimore News, Wikipedia*)

I N 1929, TENSIONS IN THE HOLY LAND WERE AT A BOILING POINT. EAR-lier, during Yom Kippur 1928, Jews brought chairs to their prayers at the Western Wall, breaking the "status quo" that banned furniture. The firebrand Muslim Mufti appointed by the British, Haj Amin el-Husseini, accused Jews of threatening to destroy Muslim holy sites on the Temple Mount in Jerusalem. After a Jewish demonstration at the Kotel on *Tisha B'Av* in August 1929, Husseini's campaign escalated. False rumors spread that Jews had attacked Jerusalem mosques and killed Muslims.

At the end of August 1929, the tensions exploded with attacks on Jewish communities in Palestine – in the Jerusalem suburbs of Sanhedria, Motza, Bayit Vegan, Ramat Rachel, in outlying Jewish communities, and in the Galilee town of Tzfat. Small Jewish communities in Gaza, Ramla, Jenin, and Nablus were abandoned. But the most furious attack came against

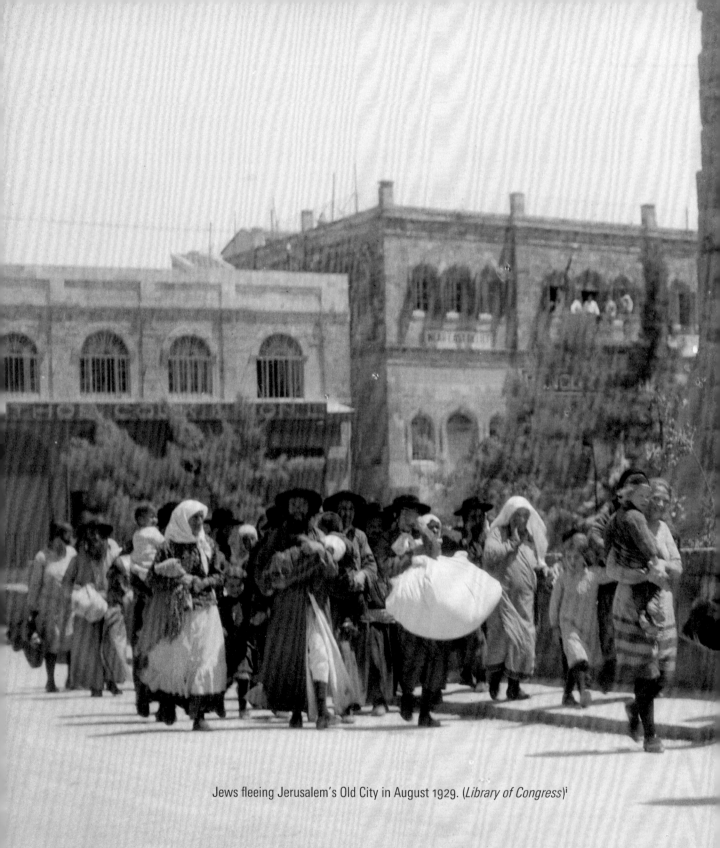

Jews fleeing Jerusalem's Old City in August 1929. (*Library of Congress*)[i]

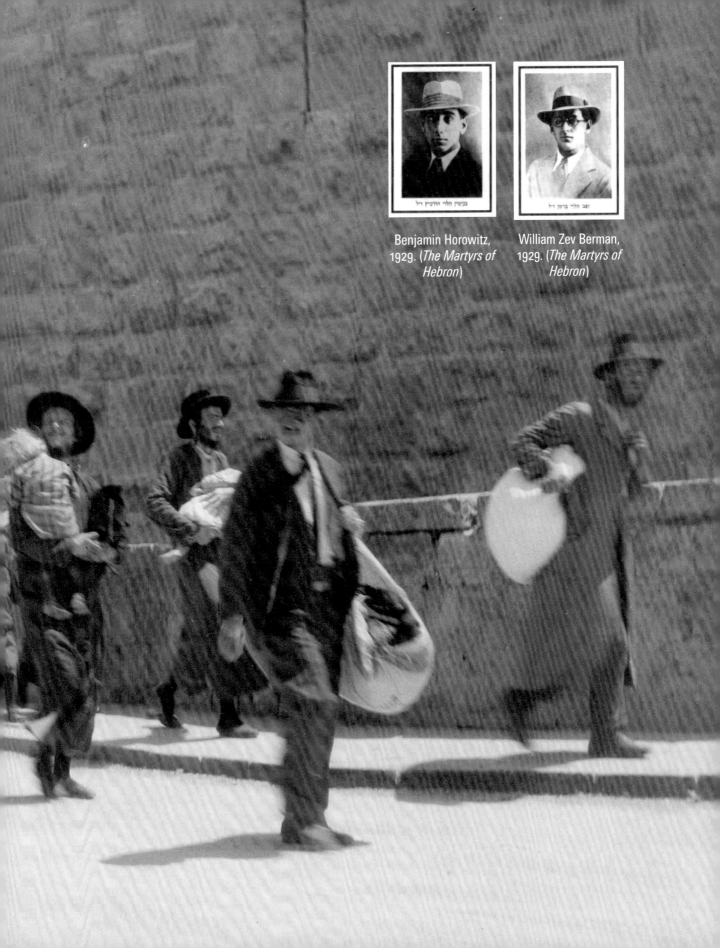

Benjamin Horowitz, 1929. (*The Martyrs of Hebron*)

William Zev Berman, 1929. (*The Martyrs of Hebron*)

the Jews of Hebron. Sixty-seven men, women, and children were savagely killed. Among them were 24 rabbinical students, including eight Americans. Witnesses claimed that British police barely intervened. Across Palestine, some 400 Jews were killed or wounded on the same day.[1]

Americans Attacked

The eight American students were William Zev Berman of Philadelphia; David Sheinberg of Memphis; Benjamin Horowitz and Wolf Greenberg of Brooklyn; and Harry Frohman, Hyman Krasner, Aaron David Epstein, and Jacob Wexler of Chicago.[2] Two were 16 years old; the others were under 23. Horowitz and Berman (pictured above) were graduates of the Rabbi Isaac Elchanan Seminary affiliated with Yeshiva University in New York.[3]

Two thousand American citizens then lived in Palestine, according to historian Naomi Wiener Cohen, author of *The Year after the Riots: American Responses to the Palestine Crisis of 1929–30*. They, their American relatives, members of Congress, and newspapers in the United States demanded action by the U.S. government and the Jerusalem consulate.

The grief and shock of the American Jewish community were supplemented by their fury when they heard the responses of U.S. Consul-General Paul Knabenshue, the highest ranking U.S. official in Palestine at the time. On the second day of the rioting, historian Cohen reported, Knabenshue told the State Department that the Jews' "provocative activities" were to blame for the violence. "According to the American official," Naomi Wiener Cohen wrote, "the Zionist actions justifiably incited the 'ordinarily law-abiding' Arabs. Studiedly ignoring any inflammatory activities on the part of the Grand Mufti . . . Knabenshue also asserted that the Western Wall was Muslim."

Cohen described Knabenshue's response to a persistent American Jewish writer. The writer and Americans who had settled in Palestine but refused

1. Naomi Wiener Cohen, *The Year after the Riots: American Responses to the Palestine Crisis of 1929–30* (Wayne State University Press, 1987).
2. Ibid.
3. Leo Gotesman, "The Martyrs of Hebron," May 28, 2006 http://www.hebron.com/english/article.php?id=254

to relinquish their U.S. citizenship needed to "make up your mind what you are, American or Palestinian," the diplomat declared.[4]

Knabenshue's anti-Zionist and anti-Semitic opinions and attitudes were well received by his State Department bosses and colleagues.[5] Whether imbued with missionary zeal or anti-Semitism, several of Knabenshue's predecessors and successors crusaded against the Christian restorationists' and Zionists' efforts to establish a Jewish homeland in the Holy Land. Twenty years later in 1948, the same bias showed itself in the repeated efforts by senior U.S. diplomats to delay and dissuade President Harry Truman from recognizing the Jewish state.

4. Naomi Wiener Cohen, *The Year after the Riots: American Responses to the Palestine Crisis of 1929–30* (Wayne State University Press, 1987).
5. Ibid.

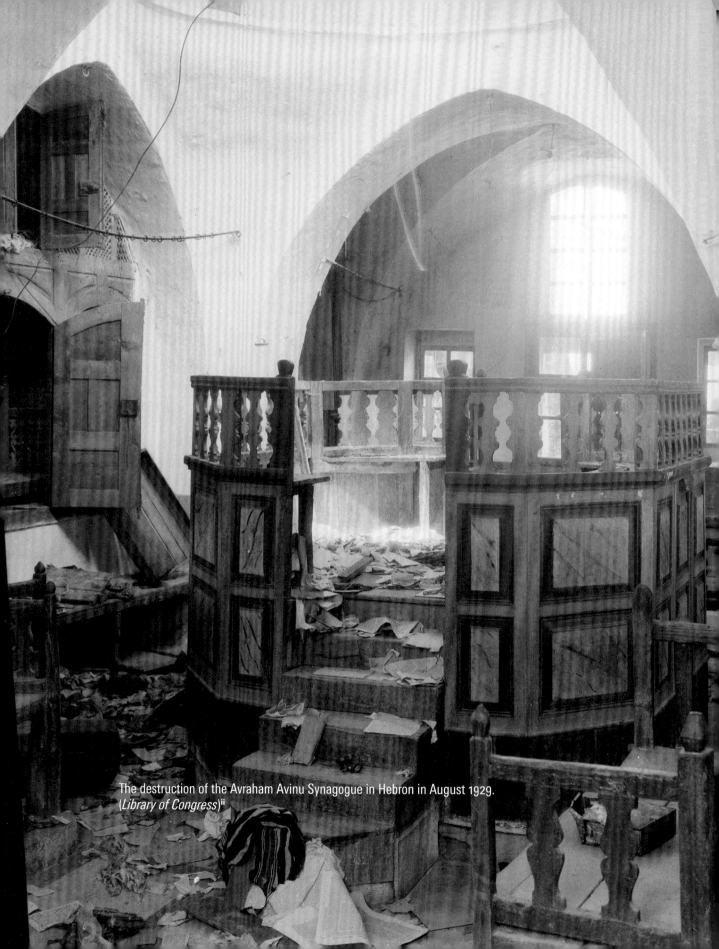

The destruction of the Avraham Avinu Synagogue in Hebron in August 1929.
(*Library of Congress*)[ii]

23 U.S. Congressional Support – before the Holocaust and Israel's Formation

April 1936 was the start of a vicious anti-Semitic and violent "Arab Revolt" in Palestine that would last through 1939.

THE MURDEROUS ATTACKS AGAINST JEWS, JEWISH COMMUNITIES, AND Jewish property were widespread throughout Palestine. British government offices, banks, and railroads were also attacked, and it was a time for account-settling assaults between various Arab factions.

Coming so soon after the 1929 massacres of Jews in Palestine and under the looming shadow of the Nazi threat, the attacks against Palestine's Jews alarmed friends of the Zionist movement. The British Mandate's policies were viewed as biased against the Jews. Rumors of a British threat to suspend Jewish immigration to Palestine were particularly worrisome.

On July 27, 1936, U.S. Secretary of State Cordell Hull cabled the U.S. Ambassador to Britain, "It has been brought to the attention of the President by influential Jewish groups in this country that the British Government is contemplating the suspension of Jewish immigration into Palestine. American Jewish leaders fear that such suspension may close the only avenue of escape for German and Polish Jews. . . ."[1]

1. Foreign Relations of the United States, 1936, page 444. http://images.library.wisc.edu/FRUS/EFacs/1936v03/reference/frus.frus1936v03.i0012.pdf

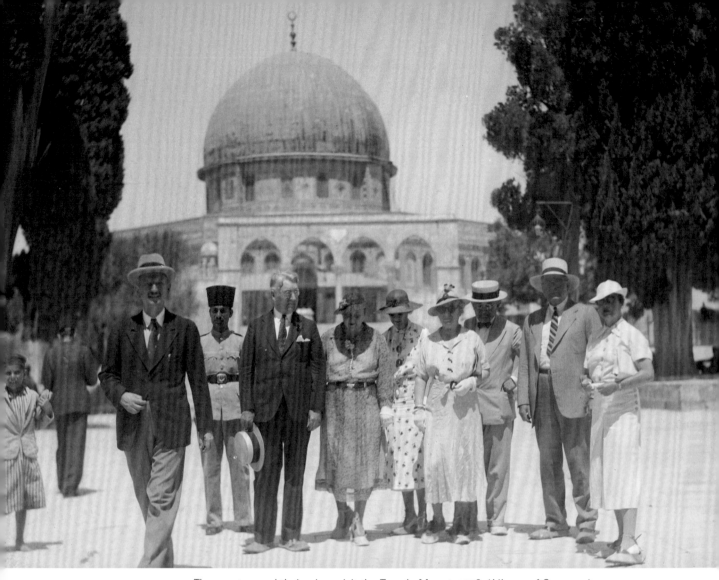

The senators and their wives visit the Temple Mount, 1936. (*Library of Congress*)

Hull instructed the ambassador to assure the British prime minister that he was only reporting on the concern of "influential Jewish circles in the U.S." and "not speaking on behalf" of the U.S. Government.

With such duplicitous attitudes prevalent in Washington and London, it was little wonder that friends of the Jewish community and the Zionist movement would react. Newspaper publisher William Randolph Hearst organized and financed a mission of three senators – Dr. Royal Copeland of New York, Warren Austin of Vermont, and Daniel Hasting from Delaware – to visit Palestine in August 1936 to "investigate the Palestine situation."

Congress' Long-Time Support for a Jewish National Home

On September 21, 1922, President Warren Harding signed into law a joint resolution unanimously passed by both houses of Congress "Favoring the establishment in Palestine of a national home for the Jewish People." The Lodge-Fish Resolution endorsed the Balfour Declaration of 1917.[2]

According to Donald Neff, a former Time Magazine correspondent and author of *Fallen Pillars: U.S. Policy towards Palestine and Israel since 1945*, the State Department responded to the Lodge-Fish Resolution like they did to President "Wilson's 1918 letter endorsing Balfour; the department simply ignored it."[3]

On August 11, 1937, Senator Copeland introduced a Senate resolution protesting British policies. The *JTA* reported:[4]

> *Condemning British proposals to partition Palestine as "outrageous," Senator Royal S. Copeland (Dem., NY) introduced in the Senate today a resolution asking the Senate's "forthright indication of unwillingness to accept modification in the mandate without Senate consent."*

Senator Copeland declared that the territory allotted the Jews in the proposed partition was insufficient to maintain even a small number of Jews and that establishment of a small Jewish state might result in a war between

2. Howard Grief, "Text of the Lodge-Fish Congressional Resolution, September 21, 1922." The Legal Foundation and Borders of Israel under International Law (Mazo Publishers, 2008). https://books.google.co.il/books, http://tinyurl.com/grxs7ru

3. Donald Neff, "Fallen Pillars: U.S. Policy towards Palestine and Israel since 1945: Chapter One: Zionism, Jewish Americans and the State Department, 1897–1945" (The Washington Post), http://www.washingtonpost.com/wp-srv/style/longterm/books/chap1/fallenpillars.htm.

4. "Copeland Introduces Senate Resolution Protesting Partition" (Jewish Telegraphic Agency, August 12, 1937), http://www.jta.org/1937/08/12/archive/copeland-introduces-senate-resolution-protesting-partition

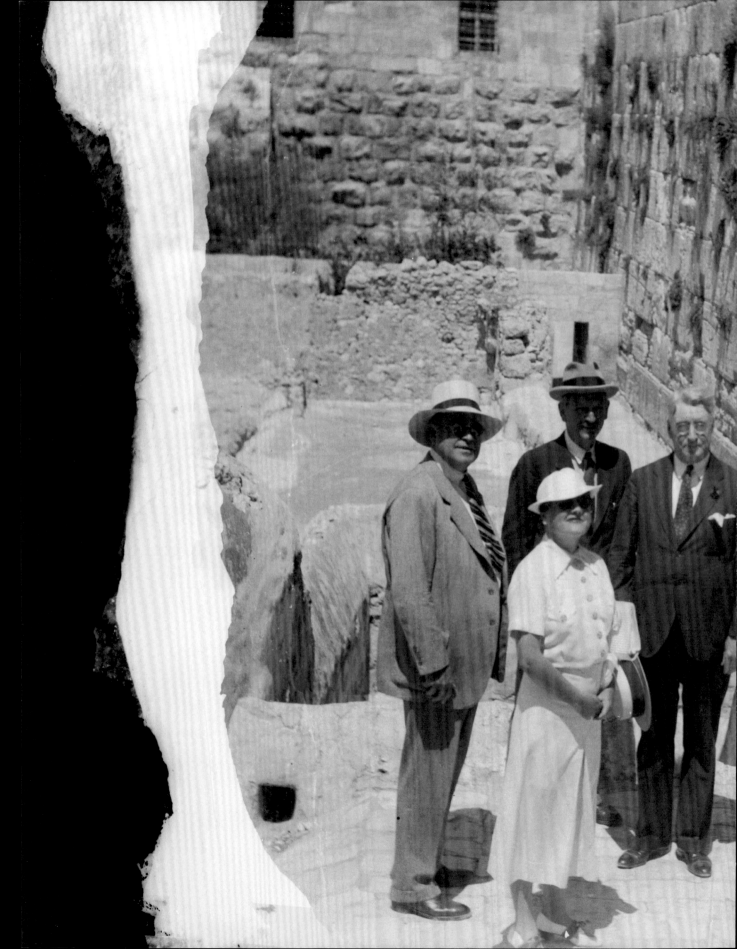

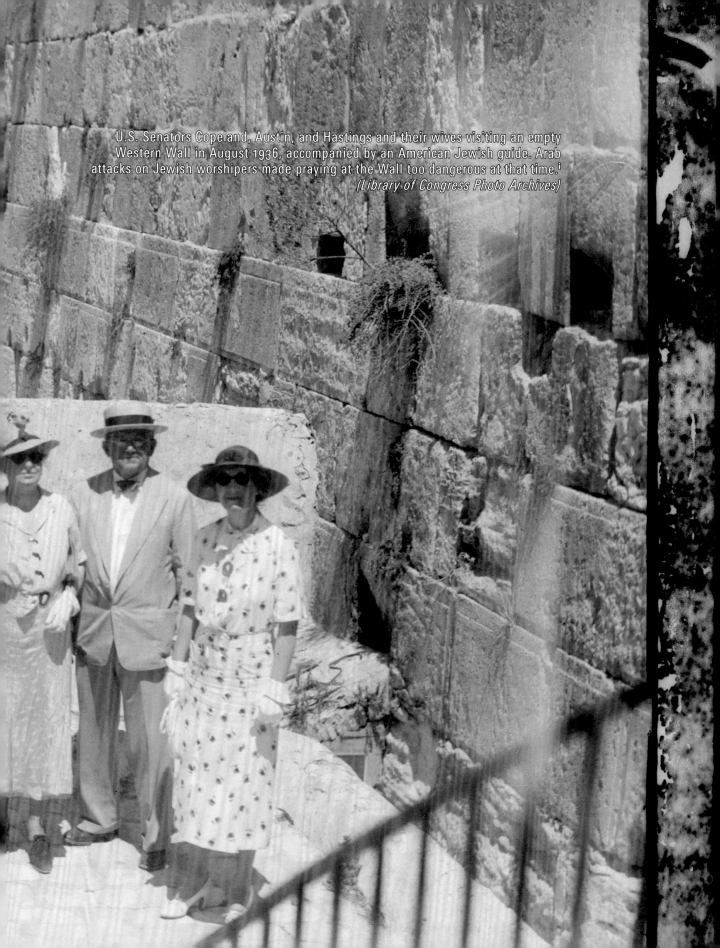

U.S. Senators Copeland, Austin, and Hastings and their wives visiting an empty Western Wall in August 1936, accompanied by an American Jewish guide. Arab attacks on Jewish worshipers made praying at the Wall too dangerous at that time.[i]
(Library of Congress Photo Archives)

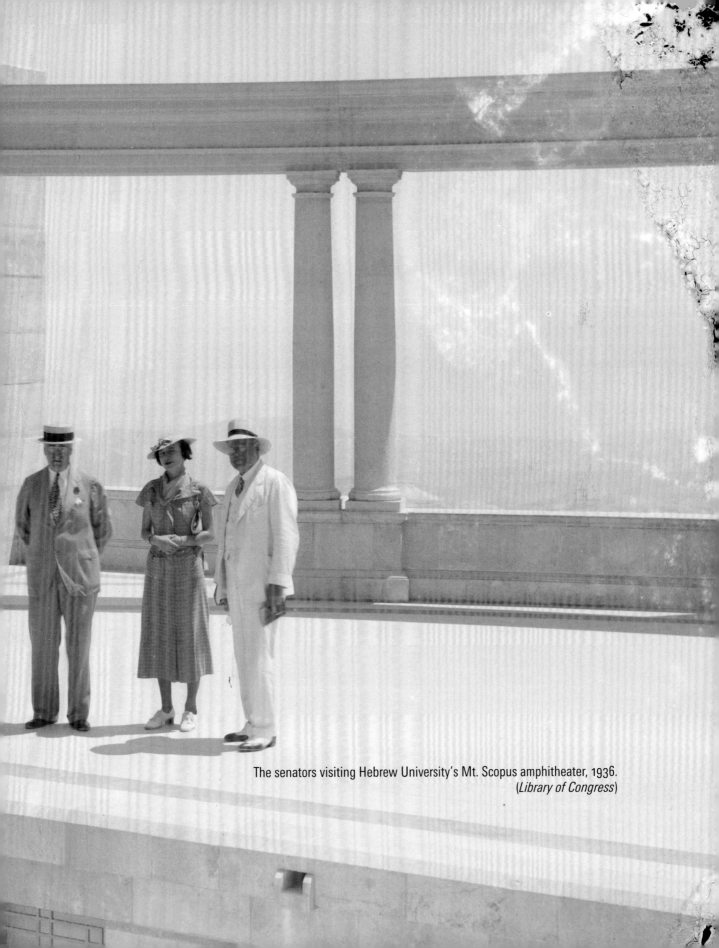

The senators visiting Hebrew University's Mt. Scopus amphitheater, 1936.
(*Library of Congress*)

the Jews and the Arabs. The Jews are having a "terrible time" in Germany, Poland and Rumania. . . . At the same time, he noted a "distinct animosity" on the part of American consuls abroad in granting visas to Jews, which, he said, showed discrimination."

On August 22, 1936, American Consul General Wadsworth in Jerusalem cabled the U.S. Secretary of State to report, "A local committee of five representative Americans (leading Zionists) has been formed to meet the [Senate] party on arrival and has planned propaganda visits to Jewish colonies before proceeding [to] Jerusalem . . . [The] junket is designed to appeal to pro-Jewish propaganda. . . . The [British] Chief Secretary of the Palestine Government takes position on grounds of safety alone that the party cannot be permitted to tour the country. With this I fully concur, particularly in view of present recrudescence of terrorism and especially as Zionists are sponsoring tour."[5]

Despite Congress' strong objections, the British government did issue its "White Paper" in 1939, imposing strict limits on the entry of Jews into Palestine, even as the Nazi monster loomed over Europe. And after the ports of Palestine were sealed, other ports of entry around the world slammed shut to the doomed Jews of Europe.

5. Foreign Relations of the United States, 1936, page 447. http://images.library.wisc.edu/FR US/EFacs/1936v03/reference/frus.frus1936v03.i0012.pdf

24 Bonus: Bobby Kennedy's 1948 Visit to the Palestine Front Lines

S EN. ROBERT (BOBBY) F. KENNEDY, FORMER U.S. ATTORNEY GENERAL and brother of slain U.S. President John F. Kennedy, was the leading Democratic candidate for president when he was gunned down at a primary victory celebration in California on June 5, 1968. His Palestinian assassin, Sirhan Sirhan, said he killed Kennedy because of his strong and vocal support for Israel.[1] Sirhan selected the day of his attack to correspond with the first anniversary of the Six Day War of 1967.

In April 1948, one month before Israel declared independence, Robert Kennedy, then 22, traveled to Palestine to report on the conflict for the *Boston Post*. His four dispatches from the scene were published in June 1948. The newspaper closed in 1956, and for decades the reports were virtually forgotten. Yellow newspaper clippings of Kennedy's articles were found by this author in a pile of discarded files in Washington D.C. They were subsequently published online by the Jerusalem Center for Public Affairs.[2]

Kennedy arrived in a chaotic and dangerous land on the eve of the British departure. Jewish Jerusalem and the Jewish Quarter of the Old City were under Arab siege and regular Arab armies were pouring into the territory. The British authorities were hampering Jews' efforts to defend themselves and were even countenancing Arab attacks against Jews.[3]

1. Sasha Issenberg, *Slaying gave U.S. a first taste of Mideast terror, Boston Globe,* June 5, 2008, http://archive.boston.com/news/nation/articles/2008/06/05/slaying_gave_us_a_first_tas te_of_mideast_terror/?page=full.
2. Lenny Ben-David, *Robert Kennedy's 1948 Reports from Palestine*, Jerusalem Center for Public Affairs. http://jcpa.org/article/robert-kennedys-1948-reports-from-palestine/
3. Colonel R. Meinertzhagen, *Middle East Diary 1917 to 1956* (Cresset Press, 1959).

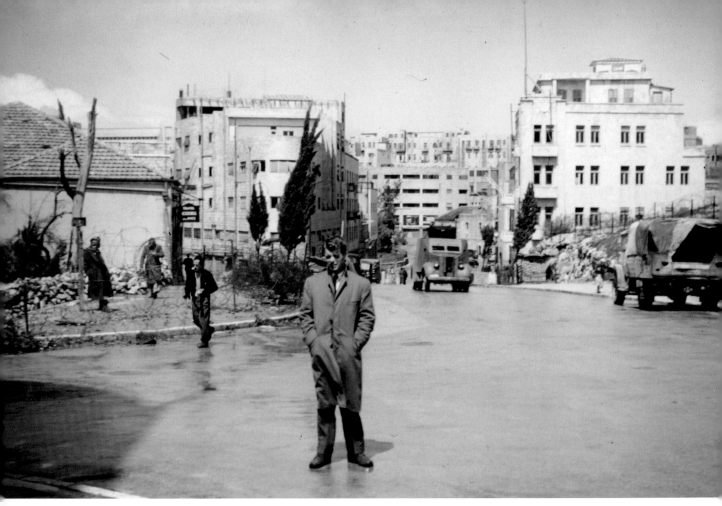

Robert F. "Bobby" Kennedy standing on Julian's Way, Jerusalem, known today as King David Street, April 1948. Barbed wire and a British Army checkpost can be seen in the background.
(Photo courtesy of the Kennedy family/RFK Memorial/John F. Kennedy Library)

Kennedy was liberal in his praise of the Palestinian Jews (only one month later did the name "Israel" and the term "Israelis" come into being). "The Jewish people in Palestine who believe in and have been working toward this national state have become an immensely proud and determined people," Kennedy wrote. "It is already a truly great modern example of the birth of a nation with the primary ingredients of dignity and self-respect."

One of his dispatches was headlined, "Jews Make Up for Lack of Arms with Undying Spirit, Unparalleled Courage." In one of his accounts, Kennedy described his travels with Haganah fighters in a convoy from Tel Aviv to Jerusalem.

The young reporter was critical of a temporary slippage of the American

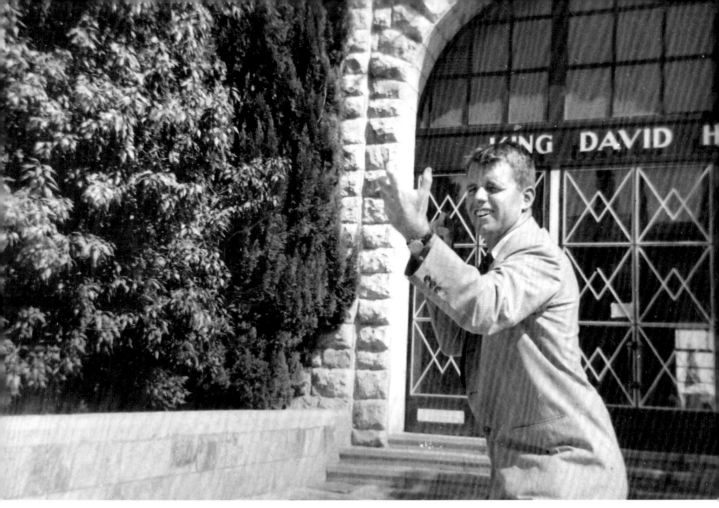

Robert Kennedy in front of the King David Hotel pretending to shoot a slingshot, April 1948. (*Courtesy of the Kennedy family/RFK Memorial/John F. Kennedy Library*)

government's support for Jewish statehood. He feared that the United States was shifting towards Britain's negative policies and its aim "to crush" the Zionist cause. "If the American people knew the true facts," Kennedy wrote, "I am certain a more honest and forthright policy would be substituted for the benefit of all."

In his biography *Robert Kennedy and His Times*,[4] historian Arthur Schlesinger, Jr. reported that during his visit to Palestine, Kennedy wrote to his parents that the Jews he met "are different from any Jews I have ever known or seen." As for the Arabs, he wrote, "I just wish they didn't have that oil." Kennedy's

4. Arthur M. Schlesinger, Jr., *Robert Kennedy and His Times* (Houghton Mifflin Harcourt, 2002).

empathy for the Jews of Palestine was all the more remarkable considering his father's antipathy to Jews. As related by Schlesinger, Joseph P. Kennedy, Sr. opposed the United States' entry into the war against Germany, and in the summer of 1942 complained to a friend, "There is a great undercurrent of dissatisfaction with the appointment of so many Jews in high places in Washington."

In the midst of the conflict, young Robert Kennedy expressed an amazing optimism in his articles: "The Arabs in command believe that eventually victory must be theirs. It is against all law and nature that this Jewish state should exist. . . . The Jews believe that in a few more years, if a Jewish state is formed, it will be the only stabilizing factor remaining in the Near and Middle East. . . . In many cases Jews and Arabs work side by side in the fields and orange groves outside of Tel Aviv. Perhaps these Jews and Arabs are making a greater contribution to the future peace in Palestine than are those who carry guns."

Bobby Kennedy landing at the Lydda (Lod) airport in 1948.
(*Courtesy of the Kennedy family/RFK Memorial/John F. Kennedy Library*)

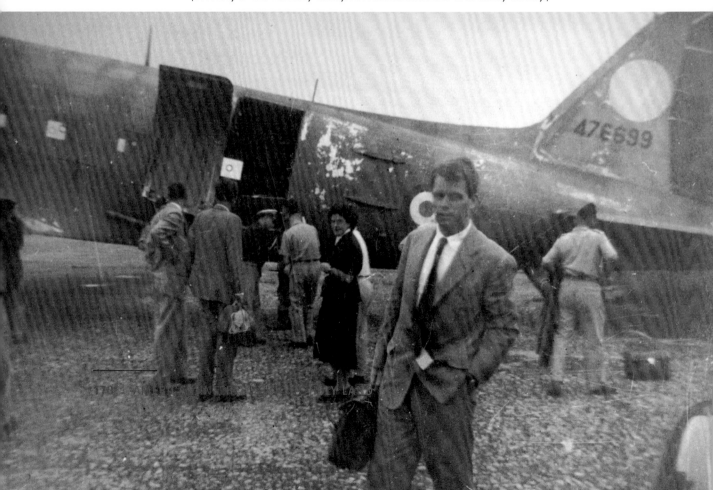

PREVIEW:
WORLD WAR I
IN THE HOLY LAND
REVEALED IN EARLY
PHOTOGRAPHS FROM
1914 TO 1919

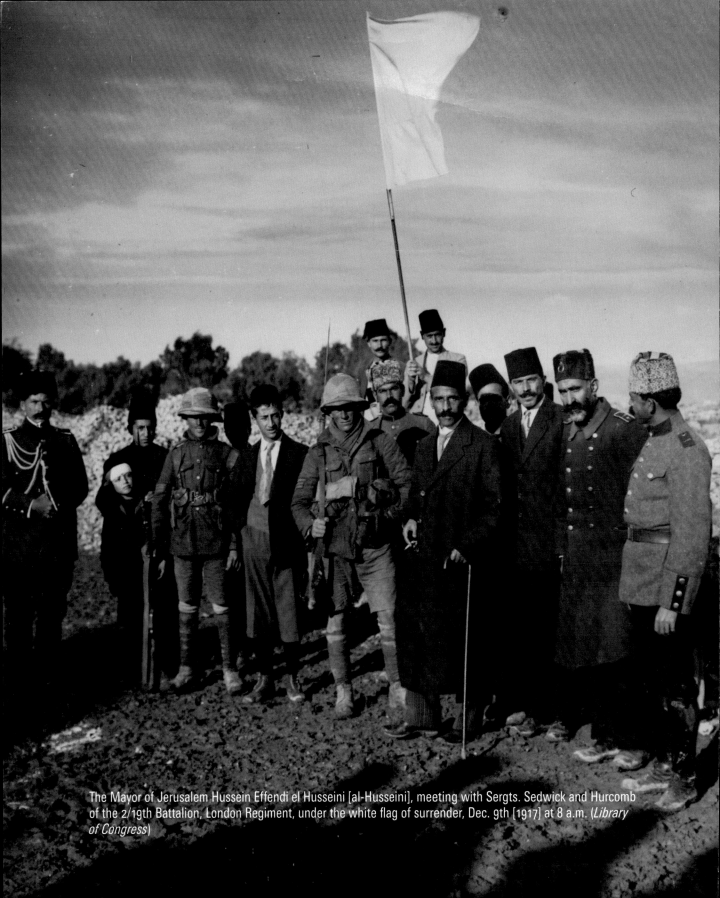

The Mayor of Jerusalem Hussein Effendi el Husseini [al-Husseini], meeting with Sergts. Sedwick and Hurcomb of the 2/19th Battalion, London Regiment, under the white flag of surrender, Dec. 9th [1917] at 8 a.m. (*Library of Congress*)

Introduction

WORLD WAR I, THE "GREAT WAR," WAS SUPPOSED TO BE THE "WAR to end all wars." It was neither. Indeed, it set the stage for World War II in Europe and the ongoing conflicts in the Middle East.

The "Western Front" in Europe attracted the most interest among journalists and historians. The "Eastern Front," however, was equally destructive, covering vast areas, killing, maiming, and displacing millions of people. Its historic significance is still being unraveled in the disintegrating Middle East today.

World War I in the Holy Land is already in production with an expected completion date of December 2017, before the centenary of the 1917 liberation of Jerusalem. As in this volume, it will contain essays and rare photographs to uncover the stories behind the war and the ultimate founding of the Jewish State in 1948.

We present here a preview of a chapter and several photographs that will appear in the book.

Lenny Ben-David

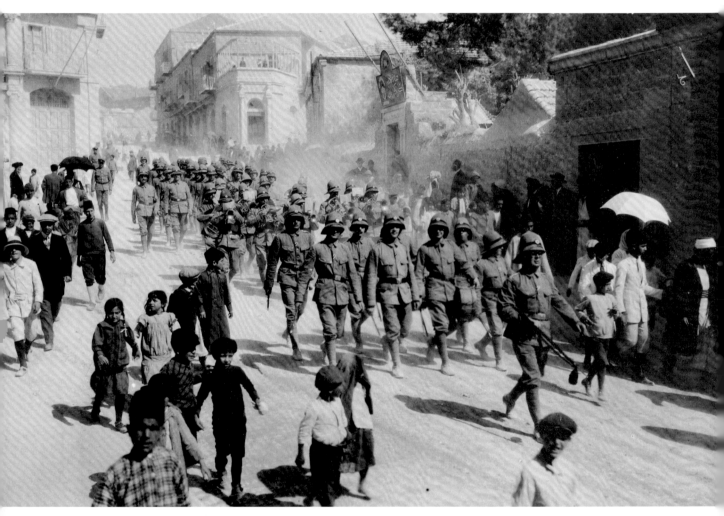

German soldiers marching down Jaffa Road in Jerusalem, 1917. (*Imperial War Museums*)

The Critical Battle for Be'er Sheva, Opening the Path to Jerusalem

Be'er Sheva under the Turks – a garrison town, 1917. (*Library of Congress*)

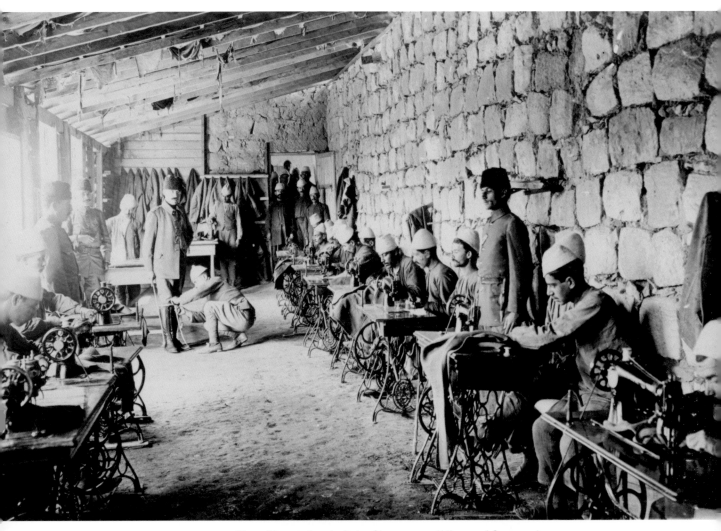

The military tailors in Be'er Sheva, 1917. (*Library of Congress*)

AFTER DEFEATING THE TURKISH ARMY IN THE SINAI, THE BRITISH army pushed north along the Mediterranean coast, but they were blocked twice by a determined Turkish army at Gaza. In a bold and difficult maneuver, the British army under Gen. Edmund Allenby sent cavalry forces to flank Gaza to the east and attack Be'er Sheva. Crossing the desert, the Australian and British cavalry had to quickly capture

the wells in Be'er Sheva before their horses died of thirst and before the wells could be destroyed by the Turks.

The desert village became the major Turkish base in the south, with wells, a rail line, military airport, logistical warehouses, and complete services for the soldiers and officers – kitchens, a flour mill for bread, tailors, boot makers, and even a newspaper. Civilian workers ran these projects.

The picture of the tailor shop was the key to an amazing discovery. A careful analysis of the photo revealed a religious Jew working on his sewing machine in the lower right corner of the picture. Why was he there? Was he alone?

Close-up of the Jewish tailor.

World War I in the Holy Land will reveal that hundreds of Jews were employed in Be'er Sheva as forced laborers or "protected workers." They worked

The daring capture of Be'er Sheva by Australian Light Horsemen, 1917.
(*State Library of New South Wales*)

on the railroad and as construction workers, teamsters, millers, laborers, cooks, carpenters, and tailors. For some, it allowed them to scratch out a living for their families in Hebron, Jerusalem, Gaza, and even the Galilee. For others it kept them out of the Turkish army. But they couldn't escape the vicissitudes of disease, flash floods, and British air raids. Dozens died; many were buried in a common grave in the Muslim graveyard of the garrison.

More details and pictures of the Jews of Be'er Sheva in World War I, the Jewish spies who aided the British, and the critical Battle of Be'er Sheva will appear in the forthcoming *World War I in the Holy Land*.

Turks await British/Australian attack at Be'er Sheva, 1917. (*Library of Congress*)

Photograph Caption Endnotes

Introduction

i. Library of Congress, Prints and Photographs, *Jewish colonies and settlements. Commencing a Jewish settlement; a camp. Jewish settlers arriving.* http://www.loc.gov/pictures/collection /matpc/item/mpc2004004618/PP/

ii. Library of Congress, Prints and Photographs, *Jewish Children*, http://www.loc.gov/pictures /item/mpc2005003518/PP/

Chapter 1

i. https://en.wikisource.org, http://tinyurl.com/jd9bqyc

ii. Tourist tents, British Library Endangered Archives Program, http://eap.bl.uk/database /overview_item.a4d?catId=198870;r=41 Image 12

Chapter 2

i. "Map of the River Jordan and Dead Sea: And the Route of the Party Under the Command of Lieutenant W.F. Lynch, United States Navy." Map, Library of Congress, World Digital Library, https://www.wdl.org/en/item/148/

ii. Tiberias, https://en.wikisource.org/wiki/File:Holy_Land_172.jpg

Chapter 3

i. Harvard University Library, "Dennis family portrait," http://via.lib.harvard.edu/via/deliver /deepLinkItem?recordId=olvwork540197&componentId=FHCL:4379531

Chapter 4

i. Brady Photographic Gallery, Library of Congress, https://www.loc.gov/item/cwp2003000275/PP/

ii. Seward, https://www.questia.com/read/98264397/william-h-seward-s-travels-around-the -world, page 652.

iii. Peter Bergheim photograph, "Jews' Wailing Place," Library of Congress, https://www.loc .gov/item/92500638/

Chapter 5

i. Maine Memory Network, "Tented settlement, Jaffa, Palestine, 1866," https://www.mainem emory.net/artifact/1185/enlarge
ii. Shapell Manuscript Foundation, "Joshua Chamberlain and William Seward Assist the Jaffa-Adams- Colonists in 1867," http://www.shapell.org/manuscript/jaffa-colonists-from -maine-receive-government-assistance-in-1867
iii. Library of Congress, "Mark Twain," https://www.loc.gov/item/2004672770/

Chapter 6

i. Library of Congress http://www.loc.gov/pictures/item/2004678589/
ii. Olivia "Livy" Langdon, 1867, This is Mark Twain, http://www.thisismarktwain.com/time line/1867.html
iii. "Group of tourists with indigenous people outside walls of Jerusalem," Library of Congress, http://www.loc.gov/pictures/item/92500662/
iv. "Group of tourists with indigenous people in cemetery outside walls of Jerusalem," Library of Congress, http://www.loc.gov/pictures/item/92500659/

Chapter 8

i. "Ulysses S. Grant," Library of Congress, https://www.loc.gov/item/96522531/
ii. Library of Congress, photo, "moving Adas Israel Synagogue," 1969, https://www.loc.gov /resource/hhh.dc0003.photos/?sp=5

Chapter 9

i. Library of Congress Prints and Photographs: "Walls of Jerusalem and the Ferris wheel looking from west restaurant pavilion, Louisiana Purchase Exposition, St. Louis, U.S.A.," 1904. http://www.loc.gov/pictures/item/97514011
ii. Gulliver's Gate promotional material screenshot from http://gulliversgate.com/viewed November, 2016.

Chapter 10

i. Library of Congress Prints and Photographs, http://www.loc.gov/pictures/item/2006676 316/
ii. "Horatio's Bible and the Prayer of the Gadites", Library of Congress, http://www.loc.gov /exhibits/americancolony/amcolony-holyland.html
iii. Library of Congress Prints and Photographs, http://memory.loc.gov, http://tinyurl.com/hv s5uft
iv. "Scribes' prayer in Hebrew", Library of Congress, https://www.loc.gov/resource/mamcol .017_3/?sp=9

v. "Valley of Hinnom, showing the Jewish Colony, Palestine, 1899." Library of Congress, http://www.loc.gov/pictures/item/2006679652/

Chapter 11

i. Library of Congress, "Walls of Jerusalem and the Ferris wheel looking from west restaurant pavilion, Louisiana Purchase Exposition, St. Louis, USA," 1904, http://www.loc.gov/pictures/item/97514011/

Chapter 12

i. Nelson B. Wadsworth, "Set in Stone, Fixed in Glass," Signature Books Library, http://signaturebookslibrary.org/set-in-stone-fixed-in-glass-7-charles-ellis-johnson/
ii. "The Jewish Community Awaits the Arrival of the German Emperor," American Colony Photographic Department, Library of Congress Prints and Photographs, http://www.loc.gov/pictures/item/mpc2004007353/PP.
iii. Nelson B. Wadsworth, "Set in Stone, Fixed in Glass," Signature Books Library, http://signaturebookslibrary.org/set-in-stone-fixed-in-glass-7-charles-ellis-johnson/

Chapter 13

i. "On the Nile, winter of 1872–1873", Theodore Roosevelt Center, (Dickenson State University, 1872–1873). http://via.lib.harvard.edu, http://tinyurl.com/zozklpt
ii. "Theodore Roosevelt on the Nile arranging transport," Theodore Roosevelt Center, Dickinson State University, http://www.theodorerooseveltcenter.org/Research/Digital-Library/Record.aspx http://tinyurl.com/h48owas
iii. Félix Bonfils, "Jews at the Western Wall," (Library of Congress) http://www.loc.gov/pictures/item/2005694944/

Chapter 14

i. Library of Congress, (LOC) http://memory.loc.gov/phpdata/pageturner.php?type=contactminor&cmIMG1=/pnp/ppmsca/18400/18415/00001t.gif&agg=ppmsca&item=18415&caption=1
ii. Library of Congress, (LOC) http://www.loc.gov/pictures/item/2008676307/
iii. Library of Congress, (LOC) http://memory.loc.gov/phpdata/pageturner.php?type=&agg=ppmsca&item=18414&seq=21
iv. Library of Congress, (LOC) http://memory.loc.gov/phpdata/pageturner.php?type=&agg=ppmsca&item=13290&seq=30

Chapter 15

i. "Water from the Jordan." (The Bee, Earlington, Kentucky 20 September, 1906). http://kdl.kyvl.org/catalog/xt795x25bz4z_6/viewer

ii. Shapell Manuscript Foundation, "Early carte-de-visite photo of longtime U.S. consul to Jerusalem, Selah Merrill." http://www.shapell.org/manuscript/cart-de-visite-photo-of-jerusalem-consul-selah-merrill

Chapter 16

i. Library of Congress Prints and Photograph department, "Steamroller on street outside walls of Jerusalem," http://www.loc.gov/pictures/item/mpc2004005988/PP/
ii. Library of Congress Prints and Photograph department, "Steamroller on Jerusalem street," http://www.loc.gov/pictures/item/mpc2004000655/PP/

Chapter 17

i. Recruitment posters, Library of Congress, http://www.loc.gov/pictures/item/2005696922/ and http://www.loc.gov/pictures/item/2003675503/
ii. Wikimedia Commons, Jewish Legion Hakotel 1917, https://commons.wikimedia.org/wiki/File:Jewish_legion_hakotel_1917.jpg. The Legion did not arrive in Palestine until 1918.
iii. Jewish Legion at Fort Edward, Nova Scotia, https://en.wikipedia.org/wiki/File:JewishLeagueFortEdwardNovaScotia.jpg
iv. Jewish Legion soldiers from the United States, 1919, http://via.lib.harvard.edu/via/deliver/deepLinkItem?recordId=olvwork472800&componentId=FHCL:3406884

Chapter 19

i. USS North Carolina, Technology Almanac, http://techalmanac.blogspot.co.il/2011_10_01_archive.html
ii. The forced conscription and looting of Jerusalem homes, Ottoman Imperial Archives, 1914, https://www.flickr.com/photos/39206470@N08/14709416521/in/album-72157645415493427/
iii. "Hangings in Jerusalem," Mitchell Library, State Library of New South Wales, Australia, http://www.acmssearch.sl.nsw.gov.au, http://tinyurl.com/z4rft9l
iv. U.S. Naval History and Heritage Command Photograph, Catalog # NH 91707, https://www.history.navy.mil/our-collections/photography/numerical-list-of-images/nhhc-series/nh-series/NH-89000/NH-89079.html
v. U.S. Naval History and Heritage Command Photograph, Catalog # NH 89079, https://www.history.navy.mil/our-collections/photography/numerical-list-of-images/nhhc-series/nh-series/NH-91000/NH-91707.html
vi. Hassan Bey, "The Tyrant of Jaffa," 1917. Library of Congress, http://memory.loc.gov/phpdata/pageturner.php?type=contactminor&cmIMG1=/pnp/ppmsca/13700/13709/00231t.gif&agg=ppmsca&item=13709&caption=230

Chapter 21

i. President Coolidge and Walter Johnson, http://www.loc.gov/pictures/resource/cph.3a33251/

Chapter 22

i. Library of Congress, "The 1929 riots. Jewish families fleeing from the Old City with bag and baggage at Jaffa Gate, Jerusalem," http://www.loc.gov/pictures/collection/matpc/item/mpc2010001213/PP/

ii. Library of Congress, "The 1929 riots. Synagogue desecrated by Arab rioters, Hebron. Furniture broken, floor littered with torn sacred books," http://www.loc.gov/pictures/collection/matpc/item/mpc2010001201/PP/

Chapter 23

i. Library of Congress Matson Collection, "U.S. Senators and their wives, Jerusalem, Aug. 1936." http://www.loc.gov/pictures/collection/matpc/item/mpc2005008055/PP/. The Senate congressional delegation was accompanied by "publicity agent" Isaac Don Levine, a journalist and columnist in Hearst's newspapers. (He appears as the fourth man in some of the pictures.)

WORLD WAR I IN THE HOLY LAND
REVEALED IN EARLY PHOTOGRAPHS
FROM 1914 TO 1919

LENNY BEN-DAVID

Forthcoming Companion Volume

Photo on front cover: The Mayor of Jerusalem Hussein Effendi el Husseini [al-Husseini],
meeting with Sergts. Sedwick and Hurcomb of the 2/19th Battalion, London Regiment, under
the white flag of surrender, Dec. 9th [1917] at 8 a.m.
(*Library of Congress*)